THE SCULPTURE OF PHILLIP KING

Tim Hilton

The Sculpture of Phillip King

The Henry Moore Foundation in association with
Lund Humphries, London

First published in 1992 by
Lund Humphries Publishers Ltd
Park House, 1 Russell Gardens
London NW11 9NN
in association with
The Henry Moore Foundation

This is the second volume in
the British Sculptors and Sculpture Series,
published jointly by Lund Humphries and
The Henry Moore Foundation.

British Library Cataloguing in Publication Data
A catalogue record for this book is available from the British Library

ISBN 0 85331 622 8

This volume has been produced with the active collaboration of the
artist and the New Rowan Gallery. The publishers would like to thank
the Philippe Staib Gallery, New York for their support. Thanks are also
due to the photographers, and, in particular, John Riddy and Victor de
la Circasia.

Designed by Alan Bartram
Made and printed in Great Britain by
BAS Printers Limited, Over Wallop, Hampshire

Contents

IN MEMORIAM
ANTONY THOMAS KING
1965-1984
IUVENIS MACULAE
INTEGER QUEM NATANTEM
CORSICA SUSTINVIT UNDA
DONEC RAPTAVIT DEUS
INVIDUS

Acknowledgements

This short book is indebted to long conversations with its subject.
Phillip King has given a number of significant interviews,
particularly at the time of retrospective exhibitions, and I have
drawn on reports of these conversations by Lynne Cooke, John
Coplans, Charles Harrison, Robert Kudielka and Rudolf Oxenaar,
to whom I extend thanks. Quotations given by these writers are
acknowledged in the footnotes. All quotations not attributed in this
way are from conversations I had with the artist in the summer of
1979 and the winter of 1991-2. These 1979 interviews were part of
a much longer series of conversations with sculptors in preparation
for a book on the history of the sculpture department at St Martin's
School of Art. I am glad to have been able to use some of this
material, and for much general encouragement I am grateful to
David Annesley, Anthony Caro, David Evison, William Tucker
and Tim Scott. It has been a privilege to have the company of these
eloquent and forthright artists. Many other friends have
contributed to my knowledge of King's work and career, even if
only in chance remarks. They include William Feaver, Bridget
Riley, Bryan Robertson, Lee Tribe and Bryan Young. Alex
Gregory-Hood's hospitality has been as much a pleasure to me as
to many others who, over the years, have visited the Rowan Gallery
and the Loxley Sculpture Garden. This project has been greatly
aided by The Henry Moore Foundation and its Director Sir Alan
Bowness – who, since the 1960s, has guided so much research into
the history of contemporary British art.

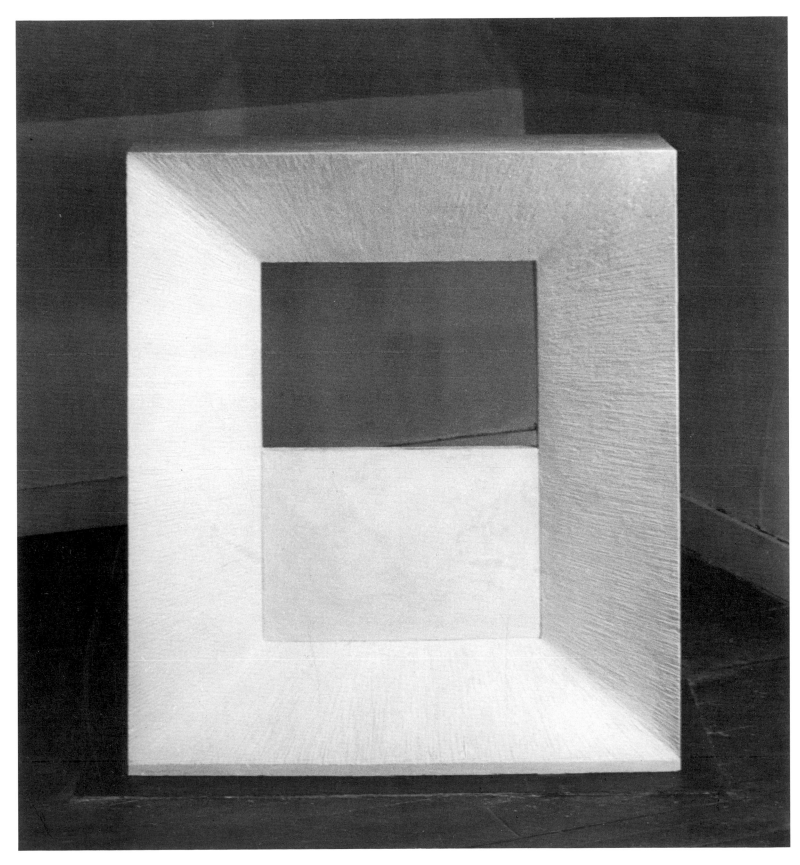

PLATE I
Window Piece 1960-1; concrete

The Sculpture of Phillip King

Phillip King was born in 1934 at Kheredine, Tunis, and is the son of a French mother and an English father: a merchant, the manager of the Société Générale Tunisienne, a coal and shipping company. Kheredine is near Carthage, two stops beyond Tunis for the little steam train that ran between desert and sea. Further along the line is Salambo, Carthage's ancient Phoenecian port and the setting of Flaubert's lurid novel. King grew up a bilingual speaker in French and English, talking to his family (there are two elder brothers and an elder sister) in either language and to neighbours and schoolfriends in French. No-one can precisely estimate the effect of his upbringing on King's mature art, yet this childhood certainly has a bearing on the sculptor's imagination.

King grew up in an exotic world, yet nothing is exotic to a child who knows no other environment. A nurse took him, at the age of seven, to the summer palace of the Bey of Tunis, Kheredine's most prominent yet private building. In its harem a dozen women offered him sweetmeats from decorated silver trays. Strong African light and the Mediterranean moon illuminated Islamic architecture. At school in Carthage he found Roman coins in the dirt playground and roamed among ruins that might have dated from the Punic wars. King remembers flocks of flamingoes on the Lake of Tunis and a summer when the lake dried up, leaving a litter of dead fish. He also recalls his first sculptural experiences. First he excavated a hole in a bank in the desert, then decorated it 'like an altar' with pieces of tinsel or other glittering matter. A place on the beach near the Kings' house had veins of soft clay. With this stuff he made pottery and animals' heads. King's fingers still have a physical reminiscence of the feel of such clay; and who can doubt that sculptures of the late 1980s such as *It's a Swell Day for Stormy Petrels* (col.pl.41) and *Where is Apollo Now?* (col.pl.43), so full of personal and unfathomable imagery, recall his Tunisian life?

The Second World War put an early end to King's childhood. While his two brothers served in the British army his father was a prisoner of war in Italy. On more than one occasion King, his sister and mother, left behind in Tunisia, sheltered from allied bombardments in an ancient Roman cistern. When peace came the family moved from Kheredine to North London. We now begin to sense the self-assured young man who would decide to become an artist. Not that King was totally at ease in London. To come from North Africa to England was to find an unlikely world of greenery, dampness, tall trees. King had no feeling for the English landscape before he was middle-aged. His father was still a wealthy man after the war but had no particular desire to buy an English house. So the Hendon Hall Hotel was King's home for ten years, while he attended (as a boarder) the nearby Mill Hill School. From this school he obtained a place at Cambridge. Of the hotel, he recalls its billiards tables. When possible, the teenaged King spent holidays in France. At about the age of fifteen he first heard, from like-minded French friends, of the current vogue for existentialism. It was a philosophical tendency that, he later discovered, 'made sense for an artist'.

King could not take up his Cambridge place for two years because of his obligation to do National Service. By great good fortune, this was a happy and relaxed period in which he found a growing commitment to art. Since he was bilingual it was natural that King should join the Royal Signals at a base outside Paris attached to SHAPE. He was paid at American rates and was able to acquire an old car and rent a small flat in Paris. This was a fine base for the exploration of the kind of life that young men find agreeable. Many months passed before his commanding officer discovered how King spent his time. He had in fact been training for his future vocation. A novel was begun, then abandoned. He bought one or two paintings and met the Belgian artist Georges Vantongerloo, a veteran of the De Stijl movement and the Abstraction-Creation group. King's love of Paris led him to photograph buildings, streets, monuments, the *quais*. His most important experience was in the Louvre, where he found that he was particularly attracted to various pieces of Greek sculpture. They were not necessarily the most dignified of classical works. Yet they interested King, and in ways that were difficult to grasp. Now, in trying to understand the nature of these sculptures, he began to draw with serious intent.

For the second time in his young life King returned from vivid experiences abroad to the comparatively staid atmosphere of English education. The reason for going to Cambridge was to please his father. Official work in the modern languages course was either too easy or irrelevant to his own interests. Most of his reading was outside the syllabus. King was struck by Albert Camus' *La Peste* (1947) – that potent fable of modern North African civilisation – wrote to its author and received courteous letters in return. This was enlivening. None the less King's main occupation in Cambridge was in making sculpture. In his three years as an undergraduate he produced some fifty clay pieces. Many were small, the smallest 3-6 inches high, but fifteen or twenty were of more ambitious proportions. King was indeed ambitious. He did not want to make sculpture as a hobby and therefore realised that he should go from Cambridge to an art school. On one of his many visits to London King was in Foyles bookshop on the Charing Cross Road and asked for information about such places. Apparently there was one next door, St Martin's School of Art. King walked in, found the sculpture department, and the first person he met was Anthony Caro. This encounter was in either late 1956 or January of 1957. In February of 1957 King was to have an exhibition of his sculptures at Heffer's bookshop in Cambridge. He sent Caro an invitation together with a return rail ticket. The older sculptor arrived at the private view, liked what he saw and once again invited King to St Martin's. Thus began the first year of King's fully adult life. He had held a one-man exhibition. Later in 1957 he married his first wife, Lilian Odelle, and when he took his place at St Martin's in the autumn he effectively joined the British avant-garde.

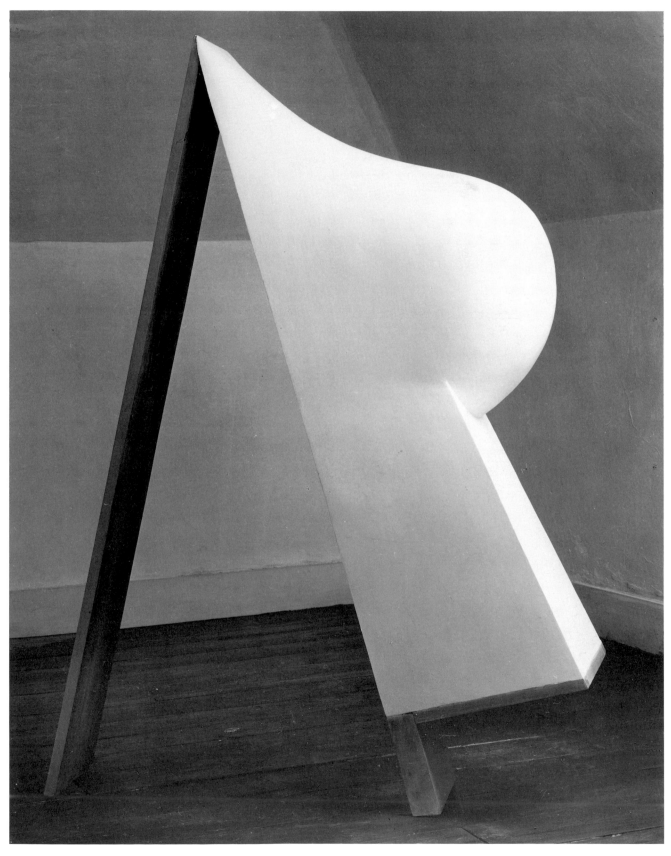

PLATE 2
Drift 1962; concrete and wood

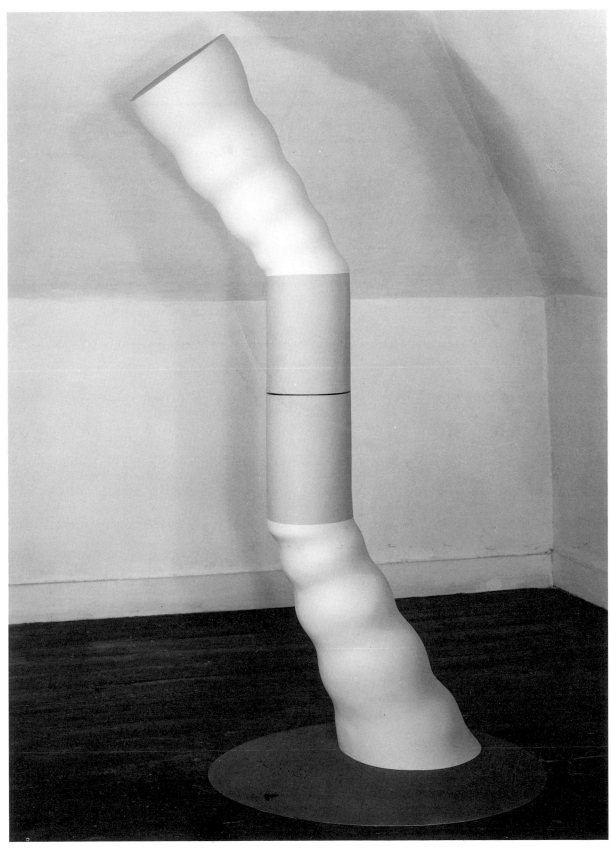

PLATE 3
Ripple 1963; plastic

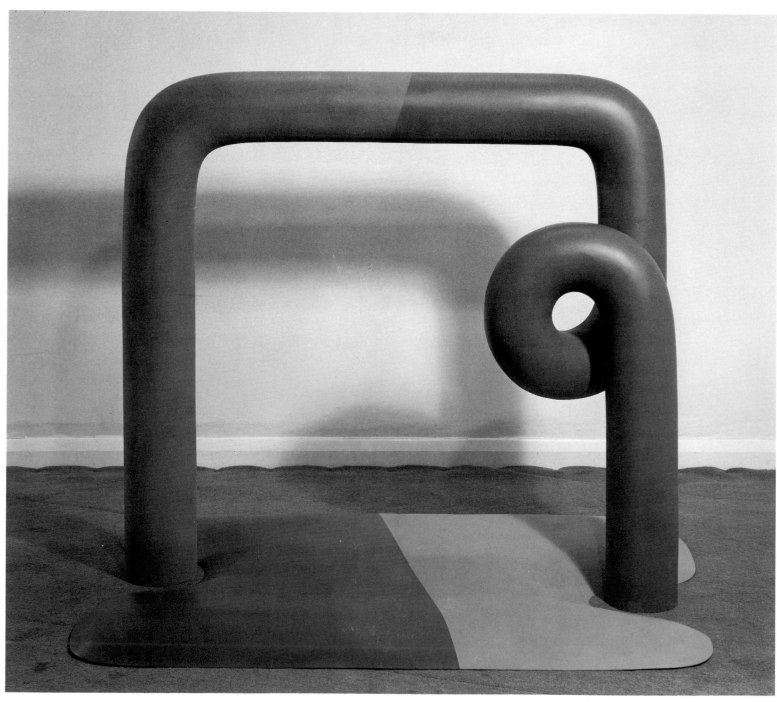

PLATE 4
Circlerette 1963; plastic

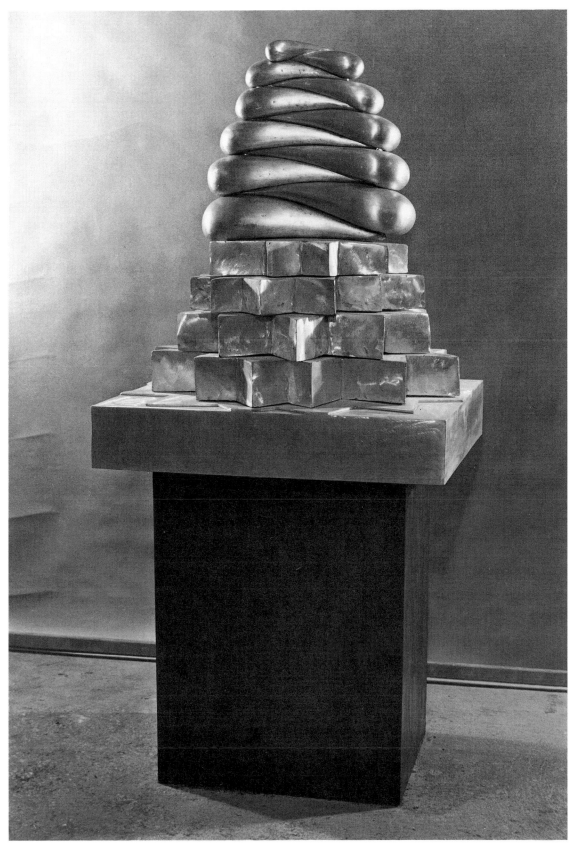

PLATE 5
Barbarian Fruit 1964; cast aluminium and steel

16

In some ways King's work in clay was already in an advanced mode, especially if considered within the context of most 1950s British sculpture. He had begun as an amateur with an enquiring mind and had little knowledge of academic conventions or craft traditions. His small figures were personal, therefore unofficial, and their visible influences were almost entirely from the School of Paris. It is as though they had been made by a displaced French artist. These pieces reflected King's studies in the Louvre and his interest in Maillol, Matisse, Picasso and Laurens. Yet his knowledge of Picasso and Matisse sculpture was not at first hand. He worked from paintings and from books of reproductions. Dependence on photography meant that scale, surface texture and treatment of volume were all bound to be erratic. King resolved such difficulties through rapid improvisation. The results were lively and quite innocent of professional training. King did not realise it at the time, but these were the ideal qualifications of a St Martin's student.

In 1957 the St Martin's sculpture department was dominated by Frank Martin and Anthony Caro, two men who had received a strict academic training at the Royal Academy Schools in the late 1940s. Partly in reaction to their own days at art school they insisted that their students should be adventurous. Caro's teaching is now legendary, and there is no doubt that the radical sculpture that came from St Martin's in the next decade was indebted to him. However, as often with legendary teachers, it is difficult to define the precepts or principles of Caro's instruction. While Martin looked after the day-to-day organisation of the department Caro acted as its energiser, ceaselessly goading students into fresh discoveries, setting bizarre projects, shouting, alternating storms of praise and condemnation. The self-esteem of a student meant nothing. Everyone had to give themselves totally to the creation of new sculpture. Caro was 'overwhelming', King found, but joins with all other former students in acknowledging his inspiration. There were no rules: a young sculptor might do anything, so long as it was done with complete commitment. At the same time there was an aestheticism in the St Martin's studios, born of Caro's high aspirations. The urgency of Caro's tutorials was in large part the result of his own frustration. He was not yet an innovative artist, and would not find his way to change modern sculpture until 1960.

Caro taught full-time students like King and also led evening classes, open to anyone from anywhere who wished to try their hand. These classes, which may have been even more outrageous in their experimentalism, brought a number of future sculptors (including David Annesley, Barry Flanagan, Tim Scott and William Tucker) into the St Martin's enterprise. King scarcely ever went to these evenings since 'I was getting most of what I wanted out of Caro during the day'. Perhaps he was also thinking that he might need independence from such a compelling yet wayward teacher. King looked for his own route by producing as many as ten or twenty small sculptures each day. Inevitably his work approached that of a number of other contemporary artists. Among them was Eduardo Paolozzi, who taught occasionally at St Martin's but, as Caro's exact contemporary, was too old to acknowledge his

leadership. At this period Paolozzi had more public success than Caro, but King was attracted to his interest in current Parisian art. He sometimes helped Paolozzi with sculptures and on one occasion they visited Paris together.

At St Martin's in the late 1950s, then, we see a highly talented group of artists with radical or revolutionary intentions but no clear idea of the best way to proceed. As we now know, the new abstract sculpture would be created by six or seven of them between, broadly, 1960 and 1963. Immediately before that innovative period there was a phase that we might interpret as part of a larger European tendency. The St Martin's evening classes were a sculptural outpost of European *Tachisme*. Like *Tachisme* in France and elsewhere the classes were wedded to 'experimental art'. Indeed, the classes lost their point if they were not experimental. In retrospect, it seems to have been a way of working that preceded a breakthrough to an assured public style. Caro made the definitive change in his art after his first visit to America in 1959. He set up a welding shop in St Martin's in 1960. This was also the time of King's first mature works. They were not welded, and were the result of quite different experiences, an assistantship with Henry Moore and important visits to Germany and Greece.

King went to work for Moore after Christmas of 1958. He had therefore been a student at St Martin's for four terms. The position had been arranged by Caro, who had himself been an assistant in the Much Hadham studios in 1951-3. King did not leave St Martin's, however, for Frank Martin asked him to conduct an evening class. He was therefore both an apprentice in Hertfordshire and a sort of master in London. He followed Moore's practice, since it was his job to execute his quotidian tasks. Yet he was also the founder of the new St Martin's dynasty, the first of many students who were asked to teach in the sculpture department after (or, often, before) the completion of their own studies.

King was impressed by the professionalism in Moore's studios and learnt the craftsmanship and studio routines built up over many decades, from Moore's own beginnings and as a teacher at the Royal College of Art and Chelsea School of Art in the 1920s and 1930s. He now learnt how to work in plaster and how to enlarge from a maquette. There was an effect on King's own art. He abandoned the handwrought clay pieces and began to think of scale and a more deliberate approach. The Much Hadham library was also important. Most twentieth-century sculptors were represented and there was an especially rich section devoted to primitive art. Yet there was an academicism inherent in Moore's practice and King was not totally convinced by the sculpture he helped to produce. It was not the modern art he wanted. This had also been Caro's experience. As he was later to say, Moore was 'the last great artist of the Renaissance'.[1] The future of sculpture was elsewhere.

King's feelings about radical modern art were clarified by a visit to Kassel in 1959, where he saw the second Documenta exhibition. Within its large and varied display were two smaller shows. They affected him in different ways. The first was dedicated to Brancusi. King already had a general idea of the Rumanian's sculpture. Now

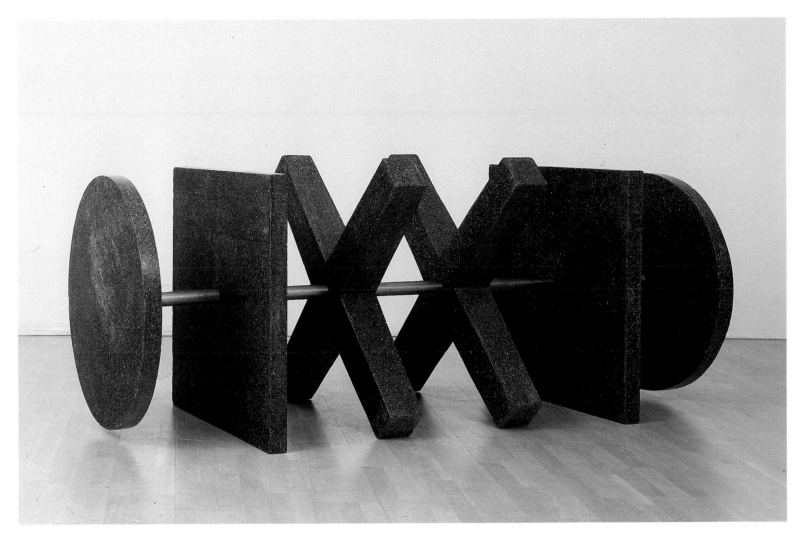

COLOUR PLATE I
Declaration 1961 ; cement and marble chippings

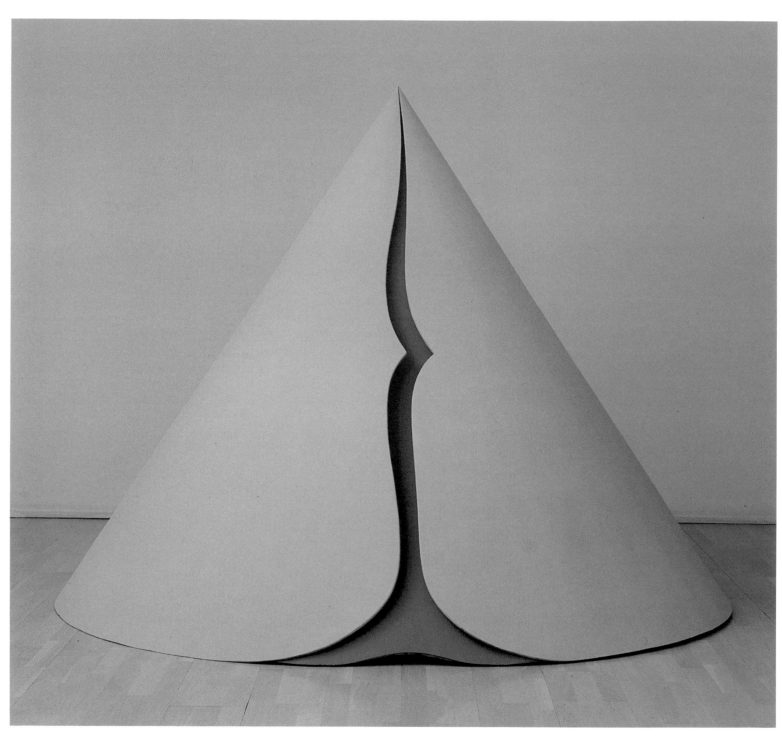

COLOUR PLATE 2
Rosebud 1962; plastic

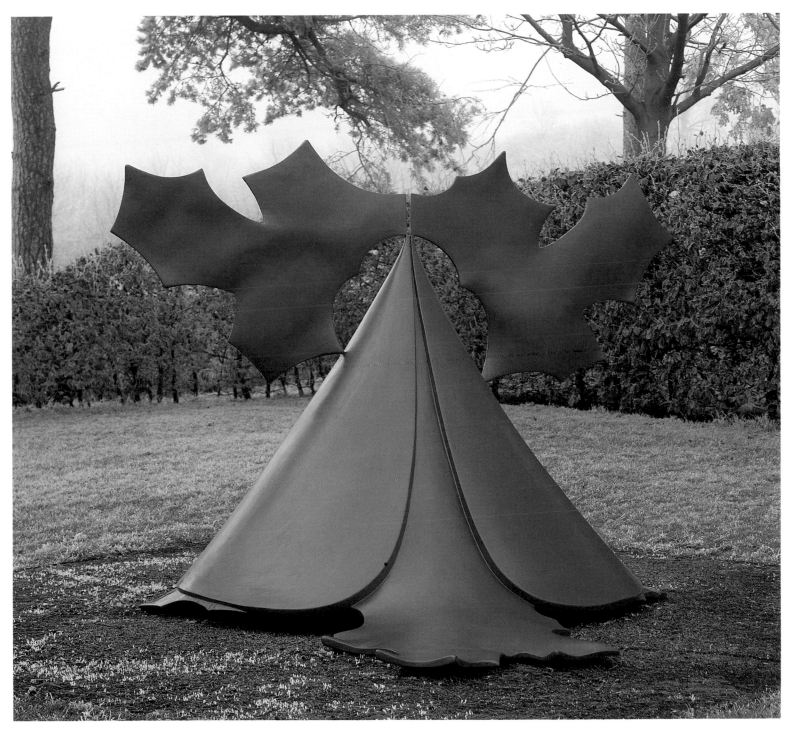

COLOUR PLATE 3
Genghis Khan 1963; plastic

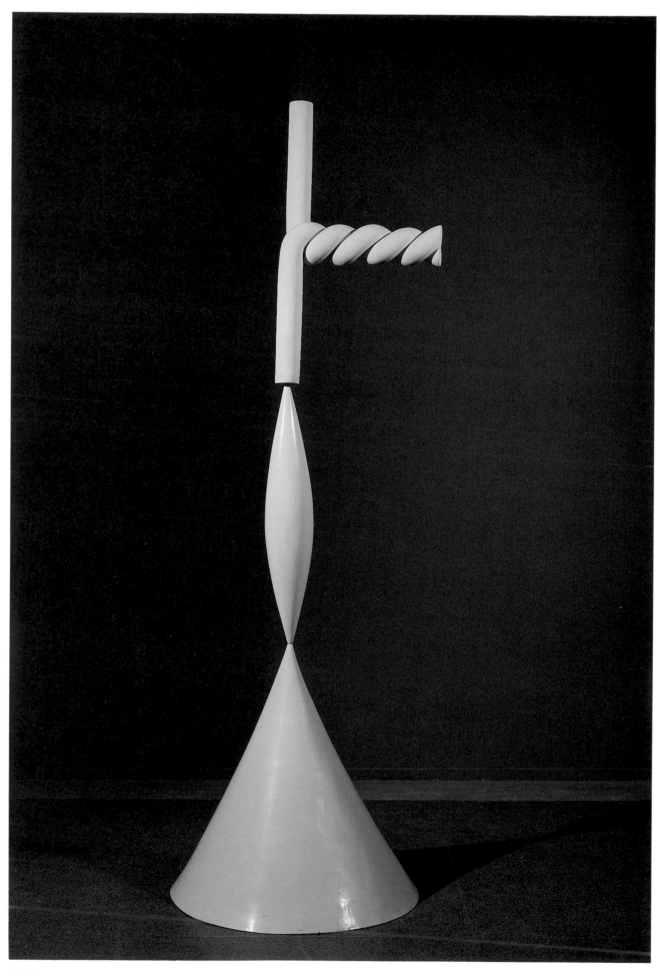

COLOUR PLATE 4
Tra la la 1963; plastic

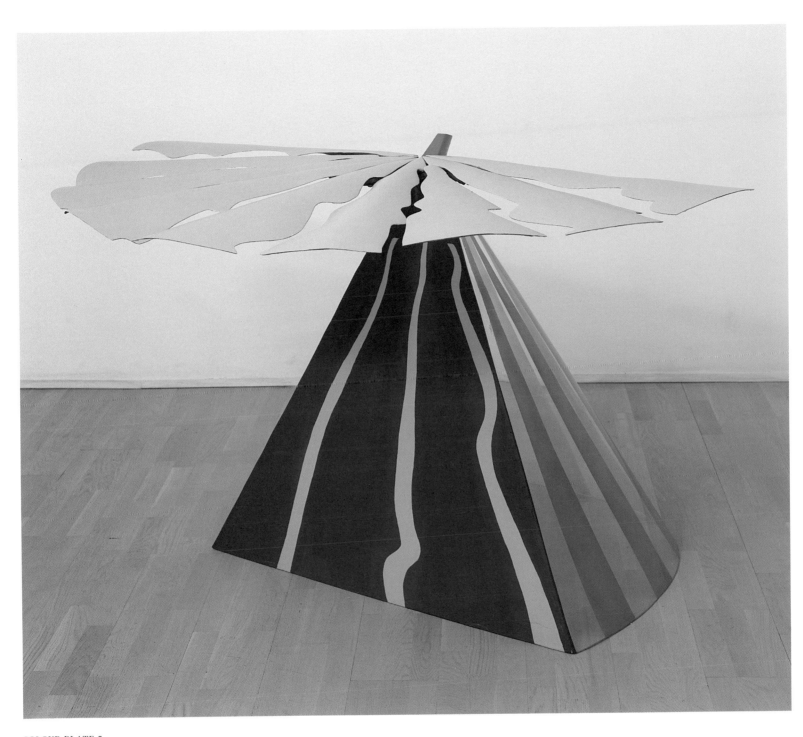

COLOUR PLATE 5
Twilight 1963; plastic, aluminium and wood

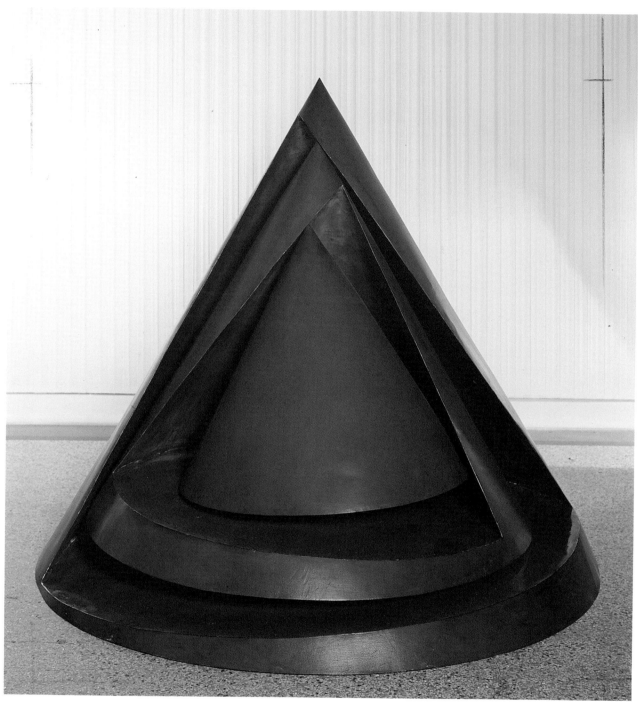

COLOUR PLATE 6
And the Birds Began to Sing 1964; steel

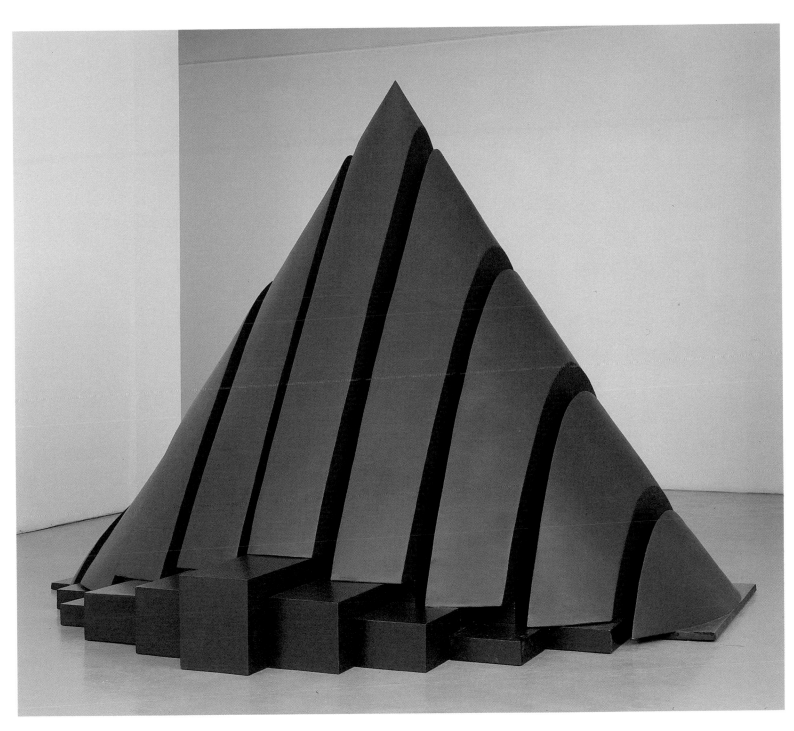

COLOUR PLATE 7
Through 1965; plastic

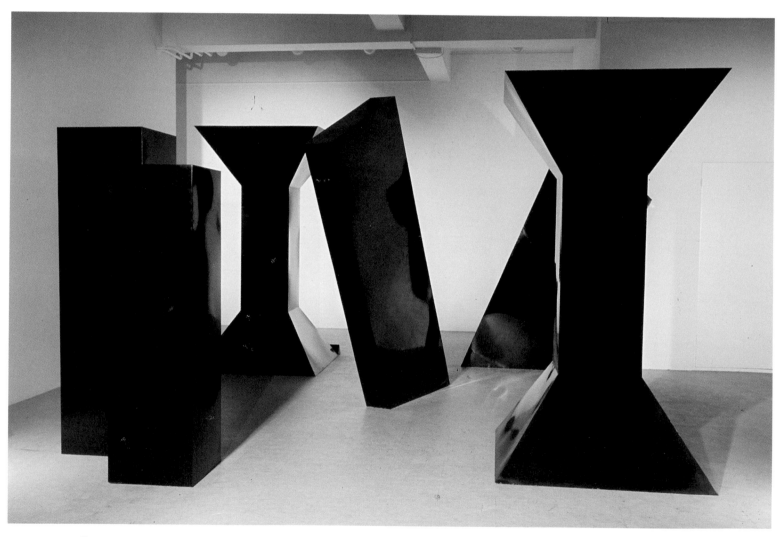

COLOUR PLATE 8
Span 1967; steel

COLOUR PLATE 9
Point X 1965; plastic

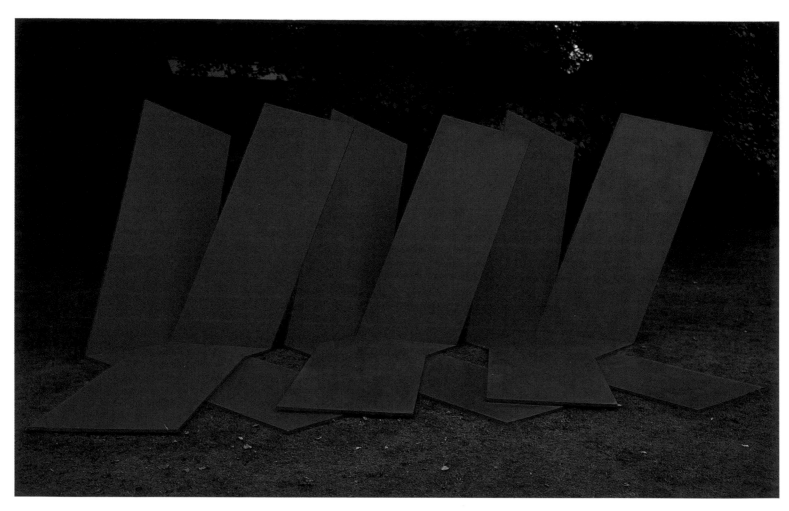

COLOUR PLATE 10
Slant 1966; arborite

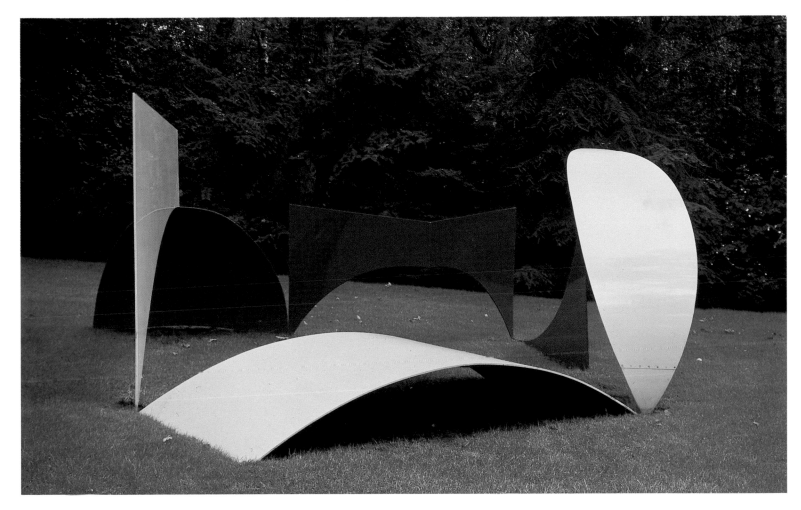

COLOUR PLATE 11
Reel 1969; stainless steel, aluminium and plastic

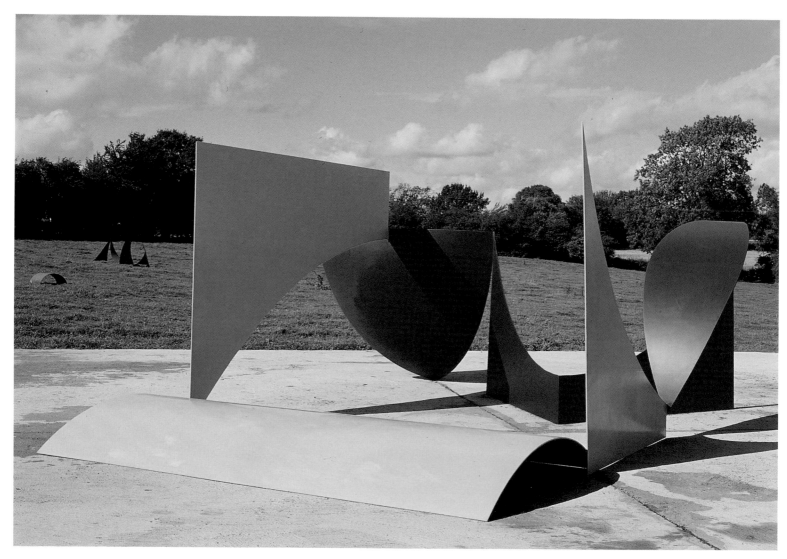

COLOUR PLATE 12
Dunstable Reel 1970; steel

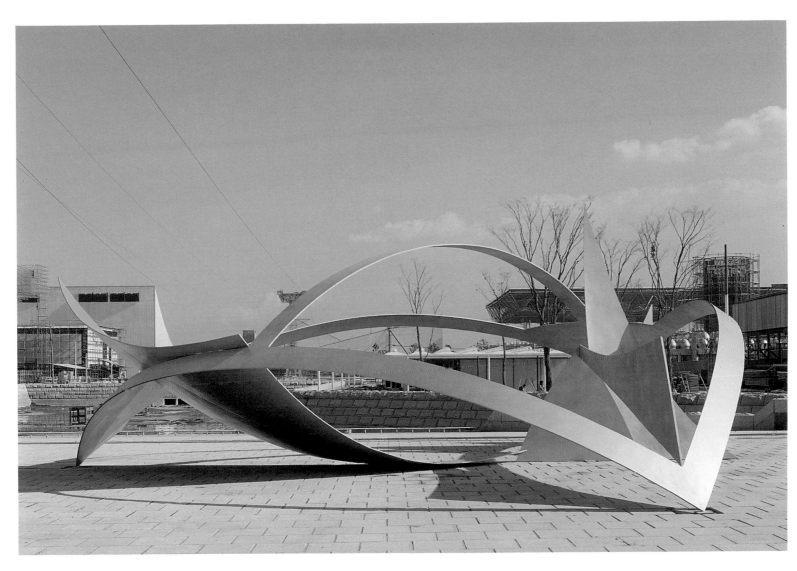

COLOUR PLATE 13
Sky 1969; steel

COLOUR PLATE 14
Call 1967; steel

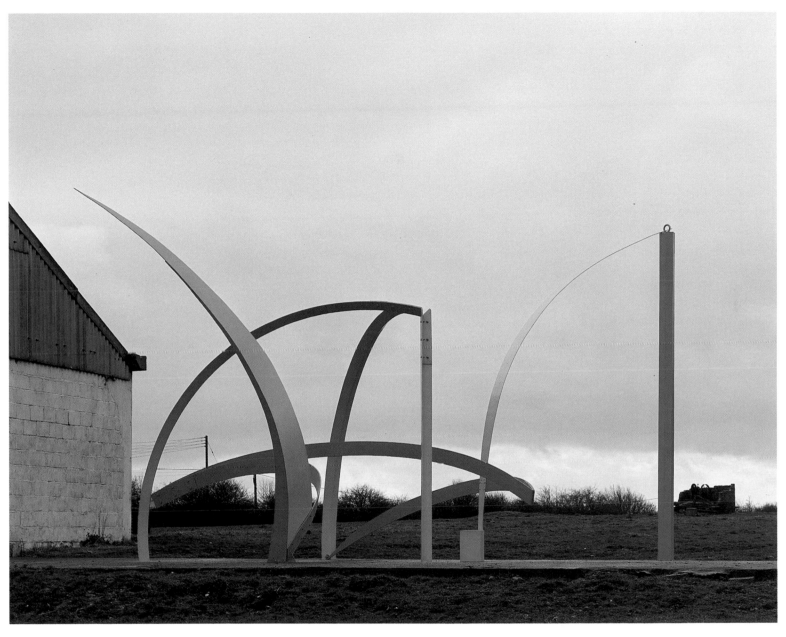

COLOUR PLATE 15
Quill 1971; steel

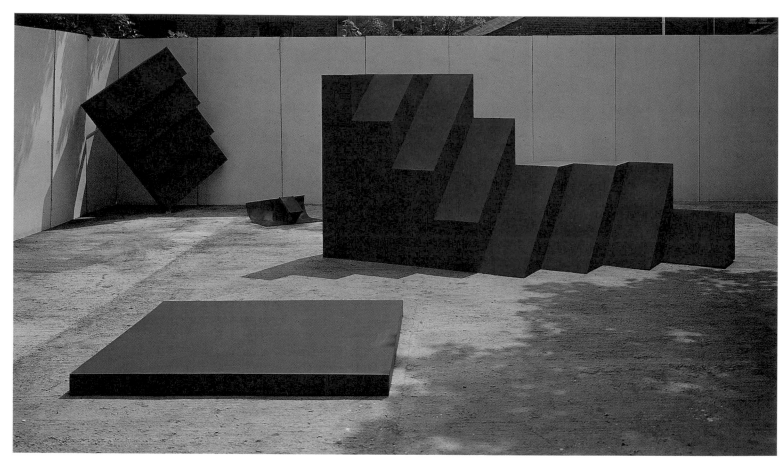

COLOUR PLATE 16
Blue Blaze 1967; aluminium

he was impressed by the grand simplicity of his forms and thought that Brancusi might have made a genuinely primeval sculpture, free from any prior influence. The second exhibition was of recent American art. This was King's first real experience of Abstract Expressionism and the painting of Pollock, Newman and Kline, among others. American sculpture had a duller appearance. King thought it was 'unoptimistic'. With a new belief that 'sculpture had to catch up with painting' he shortly afterwards made a piece that is almost a transmutation of Abstract Expressionism on canvas. This work (*Untitled*, 1960, now destroyed; ill.p.111) used lead piping and plaster. It was built from a charcoal drawing in which we see the gestures of flat, expansive American painting of the early 1950s.

The apprenticeship with Moore and work at St Martin's were quite abruptly put aside when King was awarded a Boise scholarship that took him to Greece for three months. During this sojourn he made quite as much study of architecture as of sculpture. Classical building was to have an effect on the three remarkable sculptures produced on his return to London. King's thoughts at this period are preserved in a report written for the Boise trustees. It is simply titled 'Trip to Greece' but contains the involved beginnings of a new aesthetic:

In Athens I visited the National Archaeological Museum which had a great collection of Archaic sculptures – a number of complete figures of Apollo which I admired very much and took many photographs of. The transition in the space of fifty years from the very stylized archaic figures bearing a strong Egyptian influence to the very much more flowing and complex figures of the 5th century marbles was very well illustrated ... Of greater influence to my own views and ideas on sculpture in the 20th century were my visits to the Acropolis. In the last years beginning with the Impressionists art has struggled against the literary academicism of the past and sought a closer to nature way of expression. The Cubists with their Trompe l'Œil, the Surrealists with the subconscious image, the Tachists with their emphasis on the physical act have all sought a closer to nature art ... Primitive art has come to be ranked next to Renaissance masterpieces. It is no wonder that the modern student should look towards Greek art with a certain reserve, and the first comment that comes to the mind: 'no doubt a beautiful art but perhaps too divorced from Nature'. A Mondrian or Brancusi evokes rather similar suspicions: 'not sufficiently emotional' becomes synonymous with 'divorced from Nature'. A visit to the Parthenon dispelled all such doubts in my mind ...[2]

King returned from Greece to London and St Martin's, his general base in the world, and considered what to do next. After his experience of Much Hadham, its streams and sheep, he felt 'very urban'. On the other hand, travels in Greece had made him feel that there was a messiness both in St Martin's and his own manner of working. He threw everything out of his studio, the loft of his North London house, repainted the space and began again. Three sculptures initiated his fully independent career, *Window Piece* (pl.1), *Drift* (pl.2) and *Declaration* (col.pl.1).

They are not particularly alike, and this may indicate how many possibilities were now open to abstract sculpture. *Window Piece* is the most obviously Greek, for it is an attempt to make sculpture from architecture yet with no connotation of a scaled-down ancient building. *Drift* is an unusual work with an origin in St Martin's conversations. King recalls that Caro, or perhaps someone else, had remarked that 'the very first sculptural act might have been in lifting a stone from the horizontal to the vertical'. He saw the relevance to the modern primitivism of Brancusi, who had made sculpture simply by stacking repeated forms. King thought there might be another primitive sculptural act, leaning one thing against another. Hence the nature of *Drift*, made of painted cement and wood, two elements propped against each other and connected by a simple and practically invisible piece of dowelling. Both *Window Piece* and *Drift* are experimental. *Declaration*, as its title suggests, is confident that a new start had been made. A reference to the urban environment is inherent in its material, for the sculpture is made from artificial marble chippings used by restaurant and hotel designers. Early in his career, King no longer believed that some materials are more inherently sculptural than others. But in 1960-1 he certainly did believe that sculpture should seek basic form. *Declaration* consists of two squares, two crosses and two circles, held apart from each other and threaded along a metal bar. The sculpture stands firmly on the floor and its every part is equally visible. This is probably the first time in British sculpture that repetition of non-organic forms had served as a principle of the sculpture's composition. It is an innovation that Brancusi would have recognised.

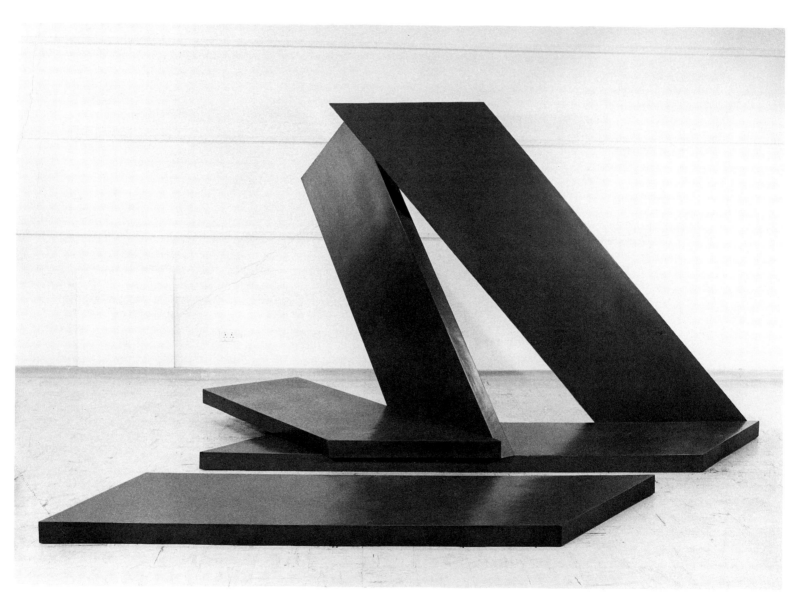

PLATE 6
Brake 1966; steel

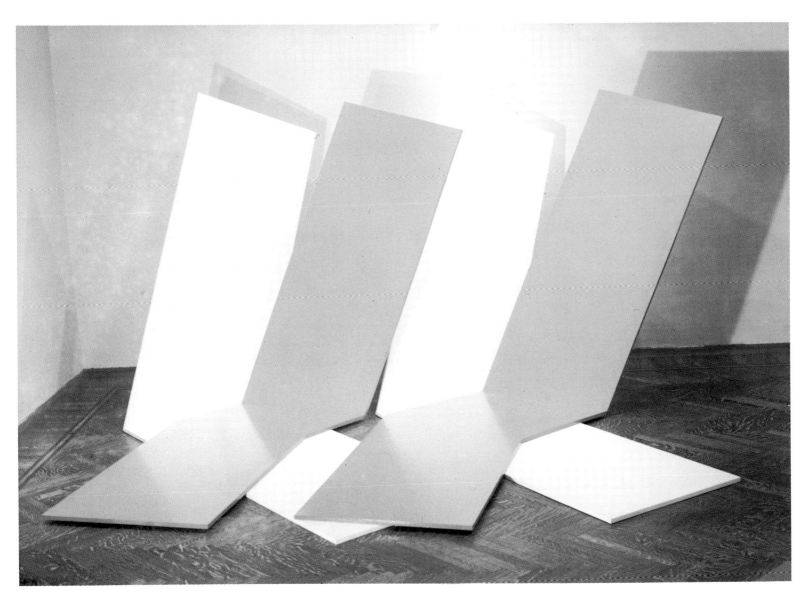

PLATE 7
Slit 1966; arborite

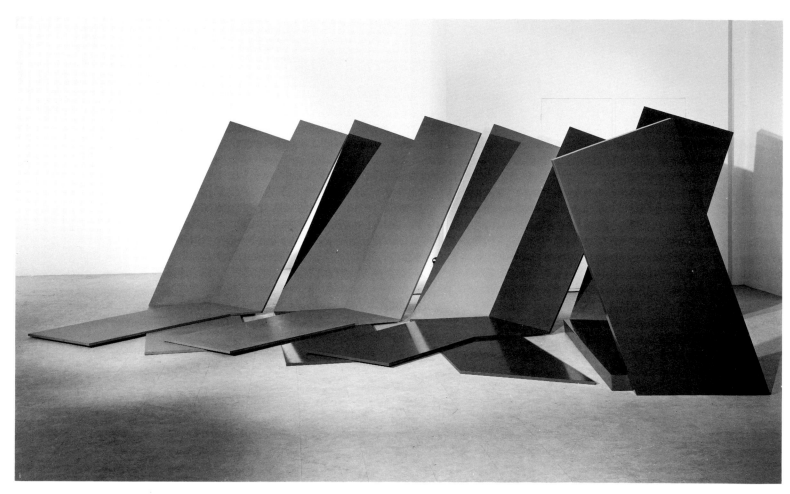

PLATE 8
Nile 1967; arborite and plastic

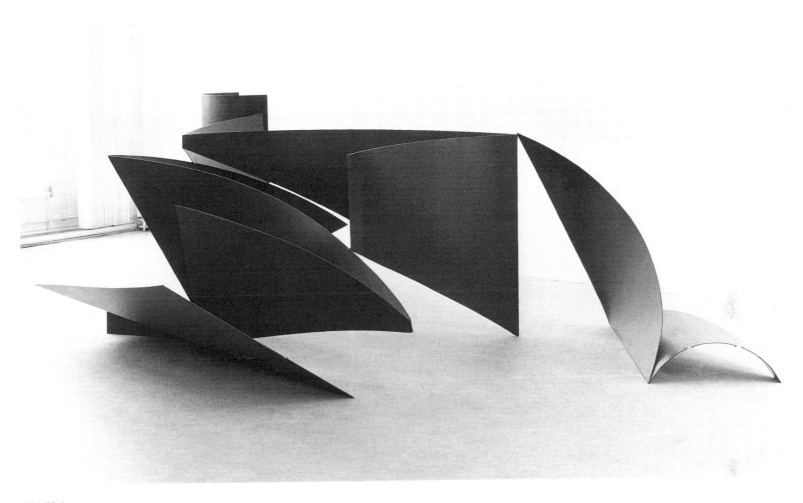

PLATE 9
Green Streamer 1970; steel

38

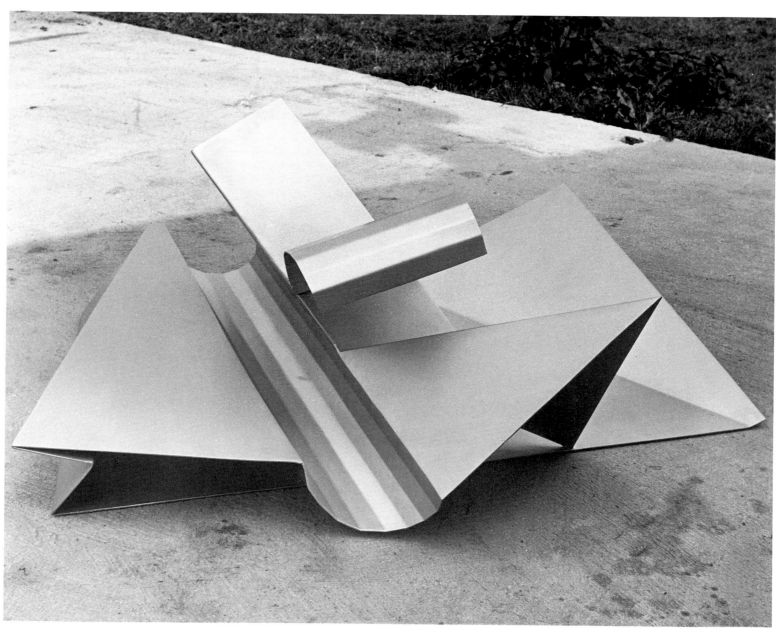

PLATE 10
Crest 1970; aluminium

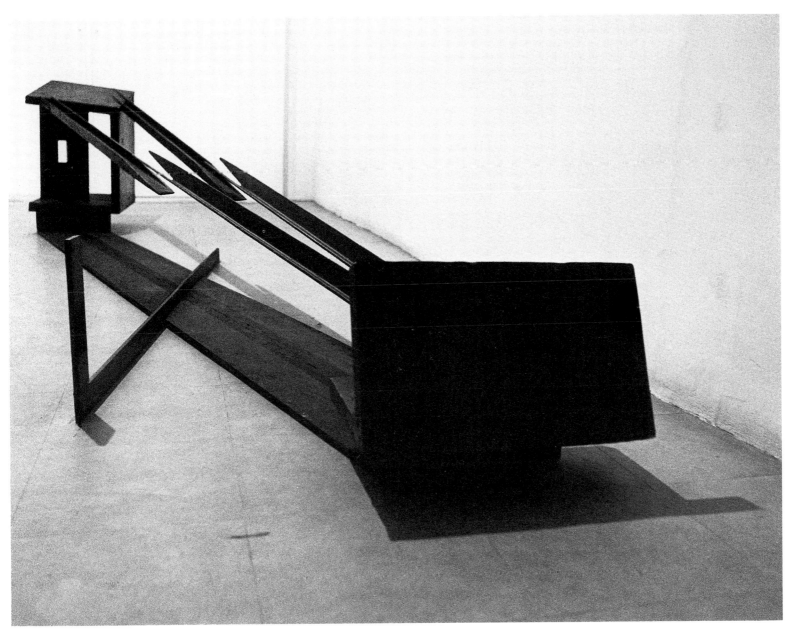

PLATE 11
Angle Poise 1973; steel

Between 1960 and 1963 (the year of Caro's one-man show at the Whitechapel) it had become clear that St Martin's sculpture was of permanent significance. We now recognise the growth of the new sculpture as an artistic movement. Caro was the most forceful innovator, but none of the first generation of St Martin's sculptors wished to model their own work on his discoveries. They had their own concerns, and Caro was the leader of a group of men who were not led. One important difference was between artists who used welding and those who developed other techniques. All Caro's sculptures were of welded steel. King had no desire to make sculptures in this way. It was an 'additive' technique. He wished, on the other hand, to reduce his expression. Like Tucker, King was inclined to pursue 'the object'. This was a word much used of sculpture (and even sometimes of painting) throughout the 1960s. What did it mean, or imply? In one simple sense, 'the object' was a pared-down abstraction. In the words of one contemporary, 'Each sculpture must have a strong *gestalt*, so that the form of the work as first perceived, from whatever angle, must make immediately comprehensible its total form.'[3] But the implications could be far wider, as may be noted in the chapter entitled 'The Object' in William Tucker's *The Language of Sculpture* (1974), a book that began as a series of semi-formal lectures at St Martin's, and which records a number of shared ideas, especially about a great sculptor whose work meant nothing to Caro, Constantine Brancusi.

This is part of the background of *Rosebud* (col.pl.2), the first of King's cones and a sculpture that – even more than *Declaration* – announced a brilliant and audacious artist. *Declaration* was magisterial and thoughtful. *Rosebud* is daring and delightful. Part of its nature is to be subversive. There was a surprising novelty in the conception of *Rosebud*, its immediate appearance and pink colour. It is also one of the first sculptures ever to be made out of fibreglass, a material already used in a commercial art department at St Martin's but taken over for King's own purposes. King later recorded of the piece 'I want people to stand aghast for a second and I hope they'll do it again and again with my best work …'[4] But when the spectator looks for the underlying principles of the piece we are returned to Brancusi. This may be a remote influence, but it is still a potent one. We reflect on how far an artistic influence can travel, and with what surprising ends.

Cones are a basic form, a solid body with a circular plane tapering to a peak. Although there are numerous variations on the theme in King's œuvre, he at no time presents a cone *per se*, an object in itself. King's cones are halved, penetrated, split, adorned or used as an unlikely pedestal. The slit in *Rosebud* King calls 'a bracketing shape'. This is illusionistic, since the shape does not in truth act as a bracket. Another illusion is the way that the sculpture suggests another cone of smaller proportions contained within the primary shape. But it is possible to imagine the sculpture without this notional core: if so it would consist of two leaves resting against each other – leaning, in fact, as the two elements of *Drift* had been set to lean. Thus King combined a basic form with his notion of a primeval sculptural action.

We should return to the nature of those 'objects' that King, Tucker and others were seeking to create. They were to take their place in a world of utilitarian things

as though worldly stability had become transparent in the permanence of art, so that a premonition of immortality, not the immortality of the soul or of life but of something mortal achieved by mortal hands, has become tangibly present, to shine and to be seen, to sound and to be heard, to speak and to be read …[5]

The words are from Hannah Arendt's *The Human Condition* (1958), a book cherished by Tucker, who recognised his own aspirations in such a sentiment. Tucker passed Arendt's book to King and to a number of other contemporaries and students. *The Human Condition* may have had as wide a circulation in St Martin's as Clement Greenberg's *Art and Culture* (1961), whose thrust was most apparent to Caro, Greenberg's friend. A difference between the books was that *The Human Condition* could give no hints at all about the sort of sculpture that might be made in the new world of the 1960s. But it could be taken as an idealistic statement of sculpture's quiddity and separateness from mundane life. One result of the study of ancient or 'primitive' art was the notion of sculpting as the kind of beautiful activity described by Arendt. A sculpture like *Rosebud* can easily be associated with the more popular styles of the 1960s. This is so of much sculpture produced by King's friends and contemporaries. But their intentions, it must be insisted, were totally serious, and there is a pronounced metaphysical strain, unspoken or not, in the St Martin's ideology.

King's considered views on sculpture were often written down and published in the 1960s and his statements show an advance on the disjointed ruminations of his 'Trip to Greece'. There are a number of reasons for this writing. First, he was a reflective and educated person. Second, King felt that ideas in general had a bearing on his desire to make art. Third, he was surrounded by articulate and literate people. Fourth, in the early 1960s there was a new demand for lectures and by the middle of the decade there would be much fuller exhibition catalogues and more responsible art magazines. Most important, however, King felt that 'It was important to write down what I believed', not only to clear his own mind but to be a new kind of professional, one who would 'distance [himself] from the amateur approach of English art'. The idea of a manifesto, 'a credo to manifest' was not unwelcome.[6]

No St Martin's manifesto was ever produced. The group had common characteristics but no shared aims. Some of the camaraderie had disappeared. By 1964 Caro was as much involved with American as with British art. King's students may have seen more of his work than did his contemporaries. More than one of them recorded that 'he seemed to know exactly what he was doing' and therefore had little need of encouragement from his peers. It is true that he became a concentrated and apparently self-sufficient artist. There are no occasional, casual or unconsidered works in King's mature career, and the certainty of his sculpture was demonstrated in each of his cones. The five that followed *Rosebud*

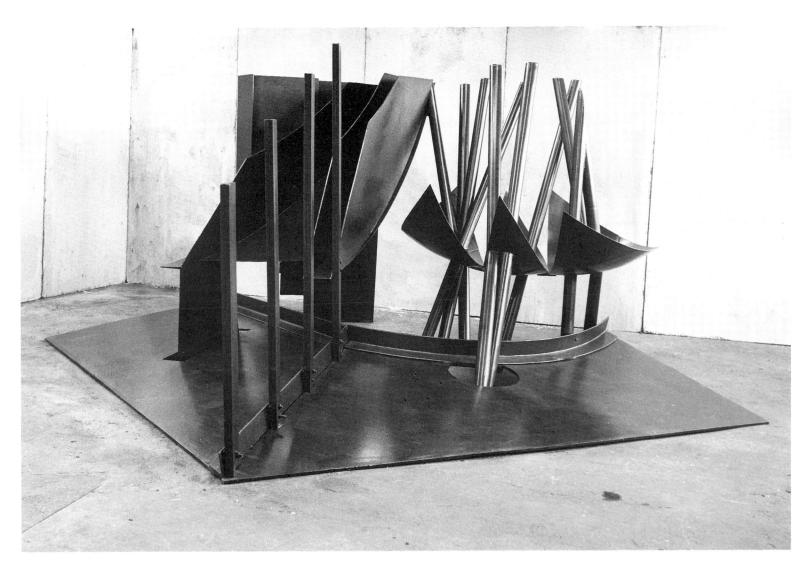

PLATE I2
Red Between 1971-3; steel

42

– *Twilight* (col.pl.5), *Tra la la* (col.pl.4), *Genghis Khan* (col.pl.3), *And the Birds Began to Sing* (col.pl.6) and *Through* (col.pl.7) – all have a different character. Each of them appears to be a summary of all that could be said on a particular topic and in a particular formal language. They are associated, but each is unique.

Twilight, the second of King's classic cones, is in some ways the most elaborate of the series, though it is the smallest of them. It makes as much use of colour as can be incorporated into the piece and is constructed of aluminium, perspex and wood. The blades that spread from the knob at the cone's vertex are quite elaborately carved. This shearing of thin metal, an idea derived from Matisse's late cut-outs, was another of King's technical innovations. Yet the piece is not concerned with the nature of its material. Nor is it resolutely abstract. *Twilight*, like many other King sculptures, is suggestive. The blades might be petals or wings. The near-metaphors of *Rosebud*, which implied organic being, floral or pod-like, are succeeded by another set of near-metaphors, of things or beings that exist freely and elegantly in the open air.

Tra la la is said to have been affected by Laurens' *La Sirène*, a sculpture known to King through its reproduction in Carola Giedion-Welcker's *Contemporary Sculpture: an Evolution in Volume and Space* (1956).[7] If so, here is a further tribute to a remote source. Beautiful, mythical sea-monsters from the straits of Sicily are considered by Laurens in 1930s Paris and further reinterpreted by King in 1960s London, not now with the sort of natural metaphor noted in *Rosebud* and *Twilight* but with an approximation to contemporary British industrial design. In *Tra la la* the cone forms the pedestal that is an integral part of the sculpture, not a thing on which the sculpture is placed. This device adds to the slightly mocking tone of the piece, if we consider it only with reference to previous sculpture on a plinth. But *Tra la la* – painted in the pale, artificial colours reminiscent of those used by British painters of the time – has no critical intention. Its self-possession is that of a dancing woman.

In contrast to this delightful sculpture, *Genghis Khan* seems to be clothed rather than stripped. Its fantasy may allude to strange natural forces, water spilling in ravines in remote mountains: hence the allusion to Coleridge's poem. There is also a temptation to call this sculpture one of King's most North African subjects, or to think of it in terms of Islamic architecture. King, unlike many of his contemporaries, was not doctrinaire about his abstraction. He did not object to the idea that his sculptures might evoke thoughts that had no strict relevance to their material existence. His 'objects' were always meaningful, and sometimes esoteric. Nor was he as opposed as some of his fellow sculptors to Surrealism, the most literary and evocative part of earlier twentieth-century art. His undogmatic response to a question about this topic was 'I would say that one could count on the fingers of one hand the artists of the 20th century that could be said not to have some sort of connection with Surrealism, in its broadest sense. I don't think I am among those few.'[8] King's hope that people might be 'aghast' before *Rosebud* and other works may be relevant to his Surrealist leanings. The cones

declare themselves quickly but their mood is elusive. *And the Birds Began to Sing*, a cone opened up to reveal two further cones at different angles, seems to have a metronomic and even merry movement within its sheltering outer form. Further experience of the sculpture suggests darker, perhaps funereal themes.

And the Birds Began to Sing was in King's mind, though not constructed, when he went to Bennington College, Vermont, in the autumn of 1964. *Barbarian Fruit* was also contemplated. Bennington in the early 1960s was both a teaching establishment and the centre of the new avant-garde. The critic Clement Greenberg and the sculptor David Smith, both of the abstract expressionist generation, were frequent visitors to Bennington because of their interest in the painters Kenneth Noland and Jules Olitski, leading figures in the development becoming known as Post-Painterly Abstraction, who were teaching at the College and working in the area.[9] Anthony Caro had joined this Bennington group in 1963. King's short term of work there introduced him to the American painters and also to David Smith, who saw *And the Birds Began to Sing* while it was under construction and commented 'Whatever you can do in fibreglass you can do in steel'. As a result of this advice the sculpture was remade in metal (by an assistant) on King's return to England. Another result of King's visit to Vermont came two years later, when he was included (with Caro) in the exhibition 'Primary Structures' at the Jewish Museum in New York. This was a display of minimal art, for which neither British sculptor felt much affinity.

The other sculpture made at Bennington, *Barbarian Fruit* (pl.5), is often said to be anomalous within the cone series. None the less it has a broadly conical outline and shares much with other sculptures of the period. The twisted shapes at its upper level, for instance, recall the plaited motif in *Tra la la*. The sculpture is mostly persuasive, however, for an exotic traditionalism. It has an air of sacerdotal gravity and an architectural relationship to the pedestal. Furthermore it belongs to a plinth, so is doubly unlike all the contemporary St Martin's sculptures that had an explicit place on the ground. An earlier version of *Barbarian Fruit* (now steel and aluminium) combined wood and aluminium in a paradoxical fashion, for the organic-looking forms are of metal while the base is of the less permanent material. This combination anticipates a later characteristic of King's art. He was beginning to demand that different materials within one sculpture obey the vision that commands their presence. Here is an attitude quite unlike David Smith's belief that truly modern sculpture could be made only with steel.

Within all the later cones, and so much of King's work of the 1970s and 1980s, there is a monumentalism and a kind of compressed architecture. The last of the 1960s cones is *Through*, once more made of fibreglass. This sculpture is cut through, from one side to the other, eight times. It is rounded, but frontal. The spectator's position is almost mandatory, opposite its tallest incision. The cuts are fairly wide, with the result that we observe the space between volumes as much as volume itself. An impression of solidity remains, and with it the sense of a monument. King has taken his modern

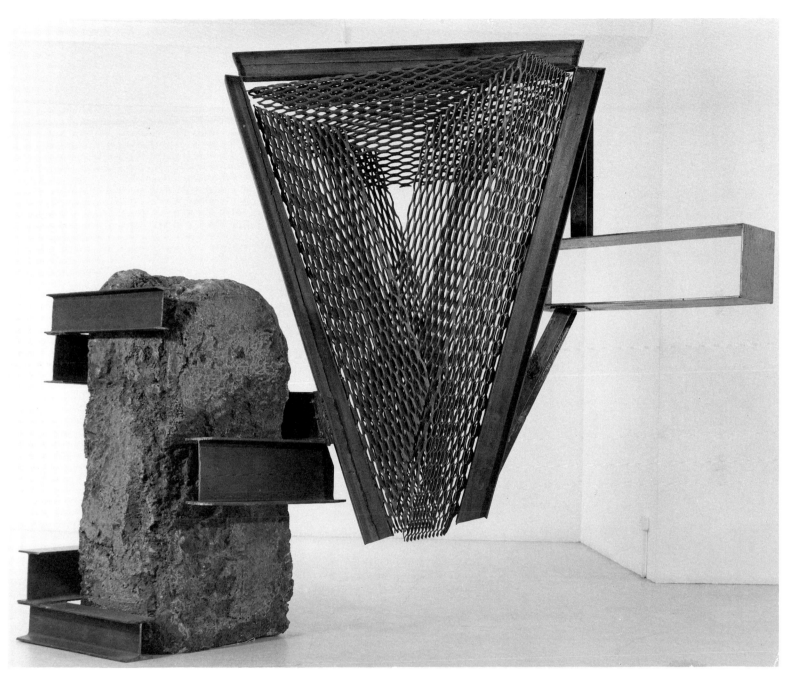

PLATE 13
Sculpture 74 1974; concrete, steel and steel mesh

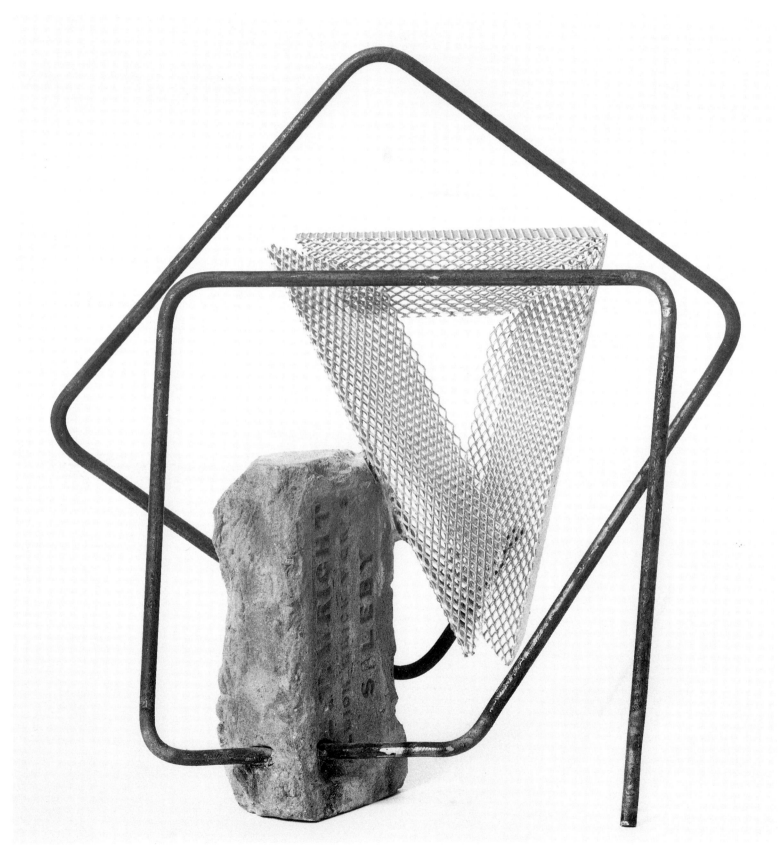

Brick Piece 2 1974; brick, aluminium mesh, steel

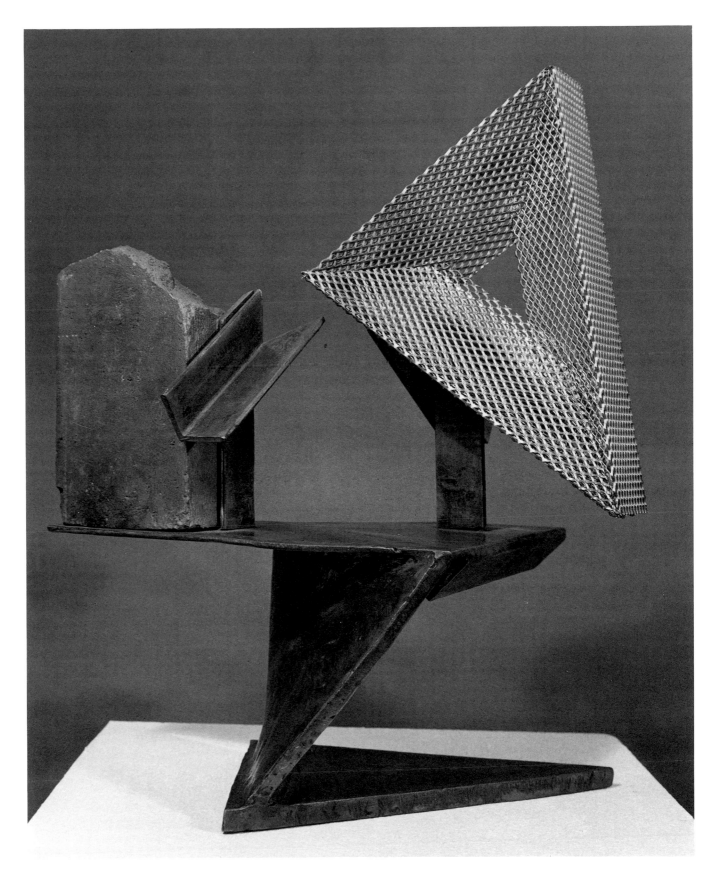

PLATE 15
Brick Piece 3 1974; brick, aluminium mesh, steel

46

cone towards the ancient pyramid, even though his sculpture is, in banal and literal terms, made up from a number of boxes. Twenty years later, a sculpture such as *The Mirror, the Bean and the Aqueduct* (col.pl.42) would replay and develop some of the themes of *Through*. None the less, in 1965 King must have felt that his cones were at an end. The next important sculpture he made was a resumption of the themes of an earlier work, *Declaration*.

The question of space in *Through* occupied King the more he considered his sculpture. The cones were, almost by definition, objects that enclosed space. They did not expand. Therefore, he explained in a 1968 interview, he needed

a jump away from the concept of the cone – which was very useful for a while to do certain things with colour – and towards new shapes which didn't have the kind of object definition that the cone has and which would allow me to open up more, to get more to grips with space. Point X is the beginning of this; it related back to Declaration in the sense that it uses very primary shapes like squares, circles, triangles, and in repeating rhythms. But suddenly the two pieces are separated – there's no longer a running axis through the centre. The axis is the lime colour running around it …[10]

That is, the central pole of *Declaration* had been replaced by something far less substantial, a colour; and a colour that is found not at the interior of the piece but at its perimeter. It is as though the heart of the sculpture had been cast to its outside edges. King adds that 'for nearly all my work colour is used very early on and goes through many stages as the piece is altered'.[11] Two colour changes in *Point X* (col.pl.9; which is made of plastic) are recorded. It was originally in blue-grey and lime but was shortly afterwards repainted in brown and lime. This lime colour is quite as unusual, even *outré*, as any previous colour in a King sculpture, perhaps in any serious modern sculpture. It is the perfect addition to the physical peculiarity of its structure. *Declaration* was natural in its balance and composition. In *Point X* the rounded elements seem to rise without the normal means of support. Were it not for the angle of the rectangular plates at its further side one might imagine *Point X* pushed against a wall. That would not be right: but one of the most tantalising things about the piece is that it seems to be only half a sculpture, yet complete.

We should now consider four sculptures whose purpose was to extend King's use of space while using regular and repeated parts and any amount of free colour. They are *Slit* (pl.7), *Brake* (pl.6) and *Slant* (col.pl.10), all of 1966, and *Nile* (pl.8) of 1967. Common to them (though there are differences in *Brake*) are thin, plate-like forms, folded in such a way that they lie directly on the ground and also tilt upwards at different angles. Their explicit themes are of repetition and overlapping. For this reason the sculptures have sometimes been associated with the minimalism of the 'Primary Structures' exhibition, as well as with the contemporary painting of Kenneth Noland and others. No doubt they belong, in part, to a period style. Within the context of King's own œuvre, however, it is appropriate to notice the way that they lean and the angles at which they are set. An unobtrusive but essential part of King's sculptural style, from beginning to end, is the way that he places things at some declination from the vertical, or twists them away from an axis or spine. Some things in sculpture are so obvious that they are seldom noticed except when they are evidently wrongly managed. Of *Slit*, *Slant* and *Nile* we may say that their complexity lies in the fineness of King's judgement of angles.

One perhaps surprising source of this preoccupation with leaning

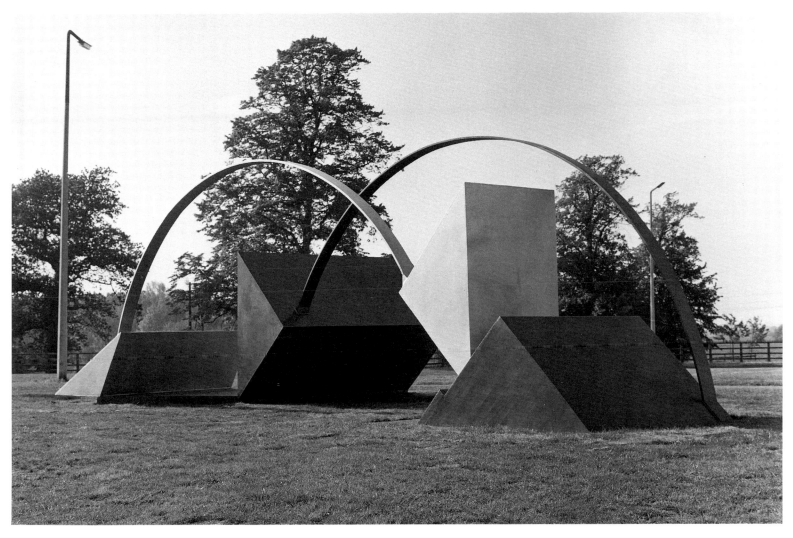

PLATE 16
Steps Sculpture 1974-5; steel

and turning is in Henry Moore, who had told King how a sculptor might deliberate for many hours over the angle at which (in Moore's case) a head or an arm might be turned from the shoulders of a figure. King has always acknowledged this lesson: of course he used it for his own ends.[12] It happened that in 1965, the year he produced *Through* and *Point X*, King was the leading figure in an exhibition generally regarded as a rejection of Moore's authority. 'The New Generation', held at the Whitechapel Art Gallery in March–April 1965, was a survey of new sculpture, organised and promoted by the gallery's energetic director, Bryan Robertson. It was one of the last of a sequence of Robertson's exhibitions that changed British attitudes to modern American and British art. All the significant artists in 'The New Generation' came from St Martin's. The show marked the ascendancy of a school that, rightly or wrongly, was said to have originated with Caro. The exhibition was also highly fashionable. Some contributors felt that they had become part of the history of publicity. Certain younger artists, most of them still students, decided that they wished to make a completely different kind of sculpture. Thus 'The New Generation' was both a rejection of Henry Moore and a stimulus to the new wave of conceptual art. 'Like all enthronements, it was the beginning of an end', King recalls.

Among King's own students at St Martin's were Barry Flanagan and Richard Long, who would soon lead the tendency towards informal sculpture. King himself took no major part in the disputes over the emerging conceptualism, though he certainly noticed how so many sculptors were now preoccupied with the various demands of a public career. His own development was both sheltered and encouraged by his connection with the Rowan Gallery, King's agents from 1964 to the present day. After the 'New Generation' exhibition King contributed to 'Primary Structures' and showed at the Richard Feigen Gallery in New York but was not much seen in British exhibitions until his own one-man Whitechapel exhibition in 1968, the year in which (with Bridget Riley, another Rowan Gallery artist) he represented Britain at the Venice Biennale. From 1966-8 he was preoccupied with a kind of environmental sculpture. This phase of his career began with *Brake* (pl.6), 1966, and continued with *Call* (col.pl.14; ill.p.112), *Span* (col.pl.8) and *Blue Blaze* (col.pl.16), large sculptures in several parts that were shown at the Whitechapel in 1968. *Blue Blaze* and perhaps *Call* were made with the Whitechapel spaces in mind.

Brake differs from the contemporary *Slant* and *Nile* in that one part of the sculpture is physically separated from the rest of the work. Such an innovation was full of risks, as many artists have found. King was unable to pursue his idea because of an instinctive architectural sense. But if he were not first and foremost a sculptor *Span* and *Call* might have been merely environmental. *Span* is a unified work. Its six parts are at some distance from each other yet their relationships are tense. *Call* is a more dispersed sculpture. While *Span*'s six elements are repeated and painted the same dark blue *Call* is made of four dissimilar parts and employs six different colours, three oranges and three greens. The best sculpture of the group, however, is the monochromatic *Blue Blaze*. The function of its colour was described by the writer Charles Harrison (who at the end of the 1960s would associate himself with the conceptual wing at St Martin's):

In Blue Blaze colour is used to better effect than in any other of King's sculptures. The combination of intensity of colours and mattness of surface ... draws attention to the disposition of forms, and thus to the whole 'shape' of the complete work ... the most dramatic contrast is not between solid and void but between blue and not-blue ... the colour unites them in their actual grouping ... They are certainly not united by what they hold in common, as forms.[13]

These sculptures in several parts probably had an effect on St Martin's students such as Richard Long. Barry Flanagan's work, particularly during the period 1975-85, has many points of similarity with King's sculpture, from *Barbarian Fruit* onwards. Yet it is best to discern King's individuality through his later self rather than in comparison with any younger contemporaries. What sculptures do *Span* and *Blue Blaze* most resemble? They are of course the parents of King's Mediterranean trilogy (col.pls 41-3), created during the late 1980s. King thinks of the elements in *Blue Blaze* as 'skimming on the surface rather than rising from the ground'. This is a theme of *It's a Swell Day for Stormy Petrels* (col.pl.41), made in 1989, and the architectural connotations of the 1960s works are spelt out – with tragic connotations – in *The Mirror, the Bean and the Aqueduct*, of 1989-90 (col.pl.42).

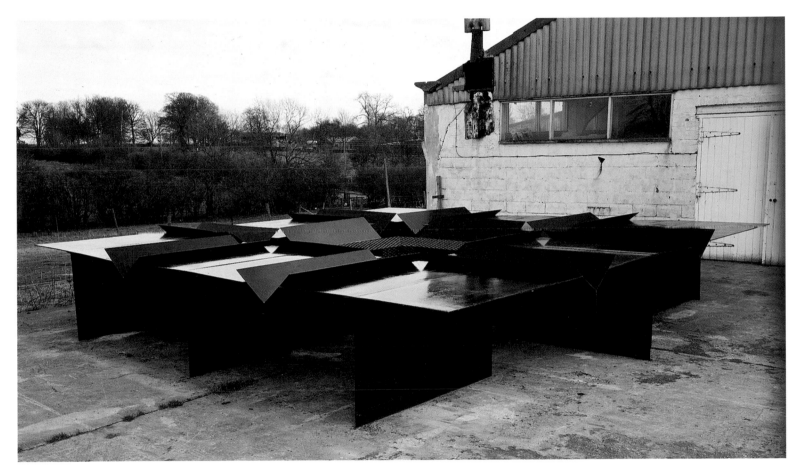

COLOUR PLATE 17
Academy Piece 1971; mild steel and steel mesh, painted

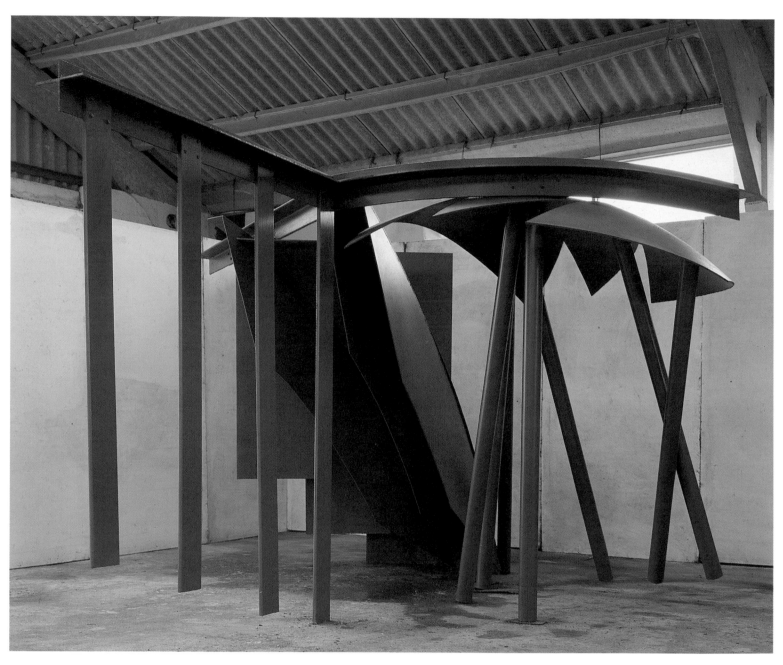

COLOUR PLATE 18
Blue Between 1971 ; painted steel

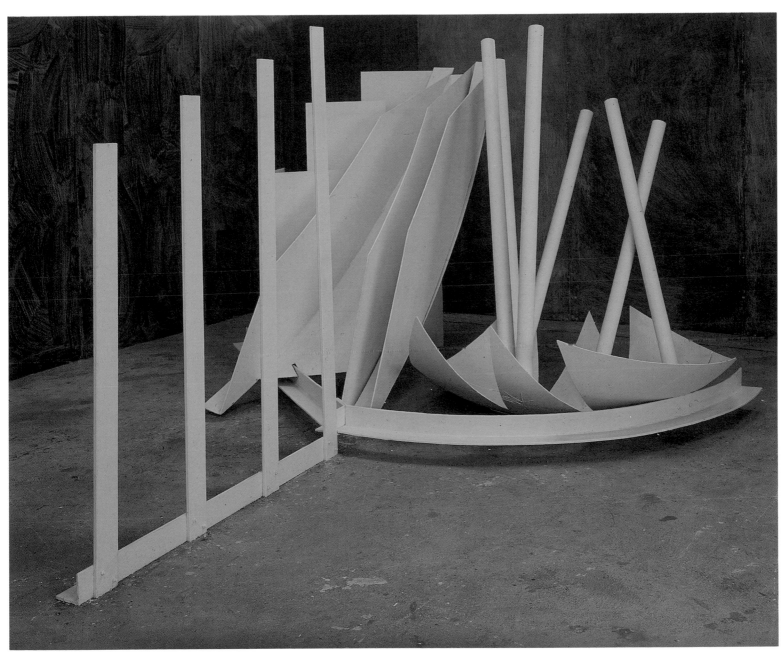

COLOUR PLATE 19
Yellow Between 1971; painted steel

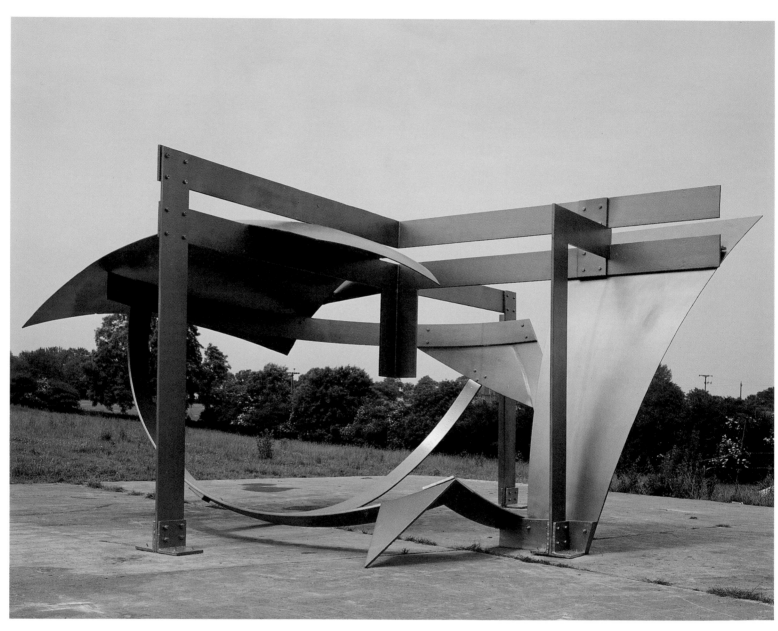

COLOUR PLATE 20
Ascona 1972; mild steel, painted

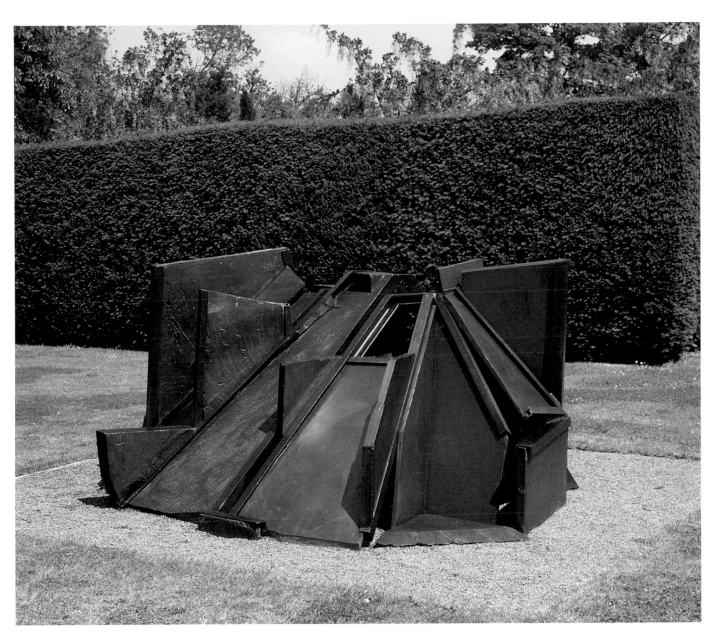

COLOUR PLATE 21
Open Place 1977; slate and steel

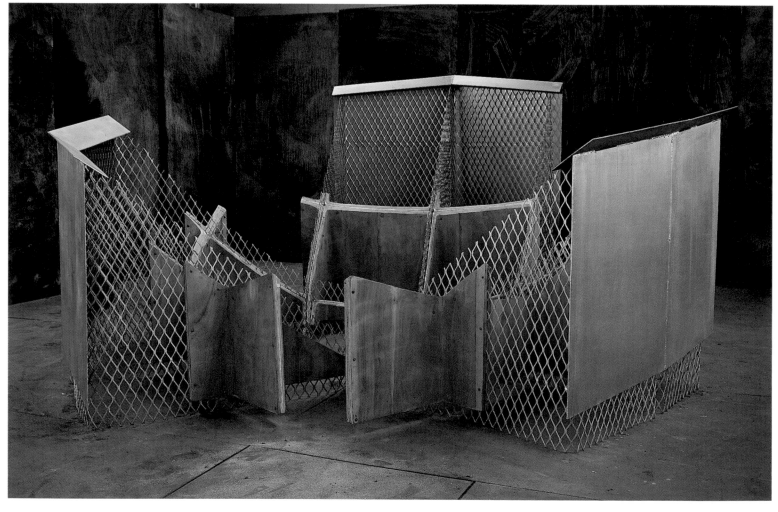

COLOUR PLATE 22
Open Bound 1973; steel, aluminium, wood, steel mesh

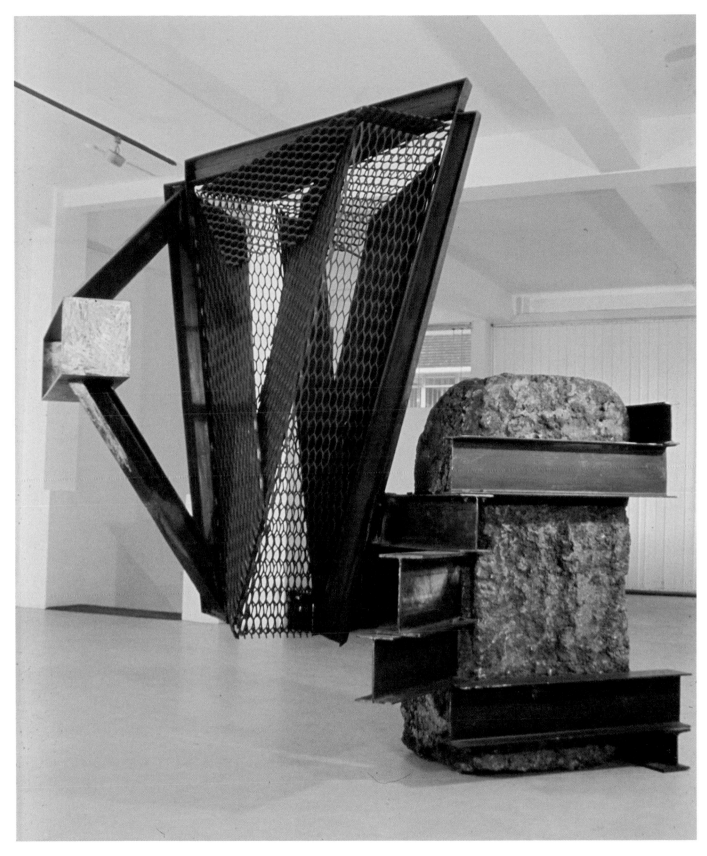

COLOUR PLATE 23
Sculpture 74 1974; concrete, steel and steel mesh

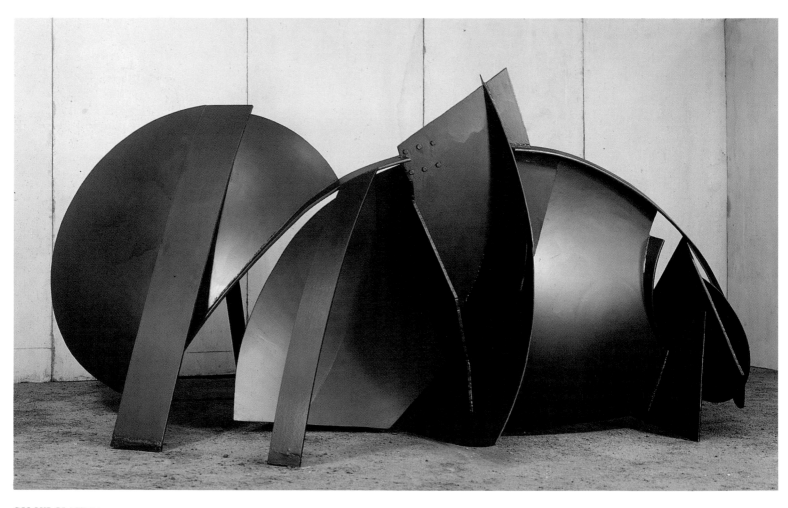

COLOUR PLATE 24
Bali 1977; steel

Late in 1967 King knew that he had to prepare for his one-man show at the Whitechapel and an internationally important appearance in the British pavilion at the Venice Biennale. These were prestigious exhibitions but King's production did not increase to meet the demands of a new audience. However daring, King is a deliberate artist. He has made much the same number of works in each year and decade of his adult life. The Whitechapel exhibition of September–October 1968 added to the Venice show of that summer with both earlier and later works. It made use of Rowan Gallery holdings and the artist's copies that King has always made of most of his smaller sculptures. This has a significance for King's later career. His sculptures are not abundant and a large proportion of his œuvre belongs to museums.

King and Riley went to Venice in the year of student revolt. Youthful Italian dislike of the Biennale far exceeded the reaction to the 'New Generation' show. Bryan Robertson recalled the Biennale as

an unfortunate affair, confused and muffled by student agitation intent upon demolishing what was felt to be a clear manifestation of international art politics, bourgeois art dealing, and promotion tactics. Most of the participating artists had considerable sympathy for this dissension and have, anyway for long depreciated the irrelevant and invidious prize systems … But it was too late for any constructive solution … Many pavilions closed down; and though the British pavilion remained open … the scene as a whole became nearly meaningless …[14]

In these circumstances King's Whitechapel exhibition was a dignified affair. He was indeed in a rather commanding position. In the previous year, 1967, King had reduced his teaching at St Martin's and taken a post at the more sedate Slade School of Art and had become a trustee of the Tate Gallery. Yet, as Robertson pointed out, his eminence was based on an output of only about twenty sculptures. The catalogue of the Whitechapel exhibition shows that he was represented in no fewer than eleven public collections. Major museums had bought work that not long previously had been under manufacture in his studio. Another success was to follow. King became the first St Martin's sculptor who was regularly given public commissions. Large public sculptures and maquettes for pieces that were never made are henceforward an essential part of his work. Noteworthy, during the next few years, are *Easter* (1968; ill.p.113), bought by a developer to go in front of a high-rise building in Hamburg; *Dunstable Reel* (1970; col.pl.12) bought by the Leicestershire Education Authority, who had already purchased *Declaration*; *Calenzana* (1972), made by King in Italy and shown in a city square in Milan; *Quill* (1971; col.pl.15) in a park in Rotterdam and *Yellow Between* (1971; col.pl.19) purchased by Alistair McAlpine, one of King's early collectors, and subsequently loaned to a new cultural centre in Adelaide.

Some of these works were purchases rather than commissions and not all of King's commissioned works were to find a place in the architecture or environment for which they were designed. Modern sculpture of this sort is put in place only after much toiling through

the slough of planning decisions. King was always aided by Alex Gregory-Hood of the Rowan Gallery, to whose skills are owed public sculptures by King in three continents. By the late 1970s King's public work was more widespread than that of any other contemporary sculptor: so widespread indeed, that this aspect of his art could scarcely be noted by his admirers.

Public sculpture accounts for the comparatively large number of maquettes in King's œuvre catalogue. In so far as possible these are made as free and independent sculptures. That is, they are works that belong to King's studio and are not dictated by the circumstances of a site. However, remote sites have their benefits. Public works gave variety to King's sculpture and encouraged a sense of scale that could be sympathetic or dominating as occasion demanded. They led to an internationalism of outlook; an internationalism that, notably, looks towards Europe and Australasia rather than America. More personal benefits of working abroad tend to be seen in later sculptures. In Japan King studied Zen gardens, and there are echoes of such gardens in the *Fire King* sculptures of 1989–91 (col.pls 39, 40; pls 36, 39, 40). In Germany he developed a feeling for the paintings of Max Beckmann, who is also an influence on the *Fire King* pieces. But the most important effect of public art on King's imagination is of a more general sort. The collaboration between public sculpture and the private studio experience helped him to develop the main theme of his later work, which is that of the personal monument.

Public sculpture enterprises are often unhappy but can have fortuitous results. In 1967 the Contemporary Art Society purchased King's *Span* with a view to presenting the sculpture to the City of London. *Span* is perfectly suited to an outdoor site but years of negotiation failed to persuade the City to find a place for the gift.[15] In 1971 a sale was agreed with the Rijksmuseum Kröller-Müller at Otterlo in the Netherlands, thus iniating the friendly co-operation between King and the Dutch museum that would lead to his retrospective there in 1974. Other pieces in Northern European public collections are the City of Rotterdam's *Quill* of 1971 (col.pl.15) and *Reel* of 1969 (col.pl.11), in the Royal Museum, Brussels. The most dramatic of this group of open steel sculptures is *Sky* of 1969 (col.pl.13), which was made at the International Steel Sculpture Symposium in Japan. Here King learnt about the techniques and facilities of the ship-building industry, with immediate effect on the scale and ambition of this eloquent and soaring work.

In Britain, the late 1960s might have been a fine period for the creation of public sculpture. But many opportunities were lost. Sculptors often exhibited new work in parks and public gardens, usually with unsatisfactory results. New Generation sculpture, with all its vital, questioning and urban outlook, was all too often relegated to such suburban-pastoral venues. King himself had to repaint *Slant* (1966; col.pl.10) in a red colour so that it could be shown on grass in Battersea Park. Paradoxically, perhaps, his new work in steel led him to the country. He found premises at Clay Hall Farm, near Dunstable, and completed the move to this new studio

in 1969. Large steel works such as *Reel*, *Dunstable Reel* and *Green Streamer* (pl.9) were made at this studio. Smaller works, often in aluminium, were largely made at a differently equipped studio in King's London home.

The group of steel sculptures typified by *Reel*, *Dunstable Reel* and *Green Streamer* are remarkable for their clarity, economy and use of colour. King's three-dimensional art makes its closest approach to painting, perhaps as a result of visits to Matisse exhibitions at the Hayward Gallery (1968) and the Grand Palais (1970). This closeness to painting is not so much in colour as in the sculptures' open rhythms and discursive composition. The space of *Dunstable Reel* and *Reel* differs from that of a preceding sculpture like *Blue Blaze* (col.pl.16): now, all elements of the sculpture are joined, even if they only touch, and they therefore enclose an open interior that the spectator cannot enter. Dance-like movements are combined with uncompromising construction. We are aware, for instance, that the sheets of metal have been cut by the sculptor's hand. This is not one of those sculptures whose character arises from the happy conjunction of found elements.

Rather, *Dunstable Reel* shows private decision. Public or personal, no sculpture by King makes any attempt to ingratiate. Two small aluminium pieces of 1970, *Crest* (pl.10) and *Quaver* (ill.p.113), both ask questions of the person who surveys them. *Quaver* may have more to do with King's later work, for here is the first appearance of the motif of rods that issue from a scooped, boat-like base. *Crest* is a tough essay on the folding of metal, and as such is the companion of the larger piece in steel, *Green Streamer*. It could be argued that some of the early Dunstable sculptures were deliberately made to contrast with works that had an assured place in a welcoming foreign location. There is little in common between Rotterdam's *Quill* and *Academy Piece* (col.pl.17), though they were both made between the same few months. *Quill* is a lovely example of King's gift for suggesting both flight and, unusually, bouncing – flight that lands and immediately lifts away from the same spot. *Academy Piece* is made of repeated elements which appear to be forced by sideways pressure. King said of the piece that it was 'a variation on the earlier Brancusi-like attempt to gain verticality through leaning. All the shapes stand up by being pushed up on three or four sides.'[16] When shown at the Royal Academy exhibition 'British Sculpture '72' this vast and severe work filled a whole gallery in Burlington House. Its difficulty might be moderated in the open air. In fact it was made out of doors at the Dusntable studio and is surely one of those pieces whose nature requires an outdoor site.

The bundle of rods in *Quaver* were elaborated and enlarged in three sculptures dated 1971 but of longer gestation, since *Red Between* (pl.12) was made in two stages separated by two years and its companion pieces were produced during the intervening period. These other two sculptures are *Yellow Between* (col.pl.19) and *Blue Between* (col.pl.18). A contemporary writer, Norbert Lynton, knew these works well and commented in 1975 that the yellow and blue pieces

are almost twin sculptures except for the all-important fact that one is an inversion of the other. The experience each offers is surprisingly different, and not only because of their differentiating colours. Briefly, Blue Between stands, hangs and hovers: tree, thicket, sky. Yellow Between feels more composed, more man-made: buildings, boats, a coming together, swift and temporary in its own yellow light ... Red Between would seem to be about energy, growth, a slow permanent springing of co-existing but disparate organisms. With its dark red colour, metallic and thus less skin-like than many of King's paint surfaces, it seems to drink the light in which it stands ...[17]

As Lynton discerned, there was an emotional variety in these three sculptures. King's work does indeed have a wide range of feeling. Other sculptors of the day, however inventive and accomplished, tended to be rather even in tone. In the mid-1970s King widened his expression, in large part by a use of materials that took him far away from steel and fibreglass. From 1973 he never used steel without combining it with wood, aluminium, concrete or slate. First, however, he made the superb *Ascona* (1972; col.pl.20) from steel alone. Its original inspiration was in the experience of working in Japan in 1969. *Ascona* was originally commissioned for a site which contained both a traditional Japanese water garden and a modern European-style house by Marcel Breuer. As work progressed in the Dunstable studio the Oriental aspect of the work faded. The commission was abandoned. Instead, we have a work that combines the discoveries made in previous steel sculptures, particularly *Sky* and *Blue Between*, and now stands as a summarising sculpture of King's steel period.

Composition with welded steel is, by its nature, frank and expansive. By 1973 he was already drawn back to enigmatic expression and his old theme of the cone. King describes the sculpture *Open Bound* (col.pl.22) as 'a negative cone'. It has an empty, circular centre, a space circumscribed by grids. They give a pattern but also demand that there are flatter and more continuous parts of the sculpture. These are supplied by aluminium and mahogany panels. *Open Bound* is named for a good reason: King wanted a sculpture that was both enclosed and gave the impression of moving outwards. 'Looseness between parts is what my sculpture is about.' Therefore we find another characteristic of King's work, a part of the sculpture separated from its parent or sibling body. At a distance from the 'negative cone' is a vertical structure King calls 'The Watcher'. He comments that this different conception is still 'like a brood of Open Bound', a symbolic part of the work because 'symbolic presence interests me'.

Without forgetting the perfect steel piece *Angle Poise* (pl.11), one looks at King's mid-1970s sculpture with growing fascination, and indeed apprehension, as he sought to create new monolithic forms. Does not the experience of twentieth-century art suggest that the monolith cannot be re-invented? All King's innovations now contain metaphors of disaster and destruction, as though he had delved into geology only in order to demonstrate that the crust of the earth cannot be mended by human labour. Not only did King use ancient materials, in particular slate and sapless wood, his

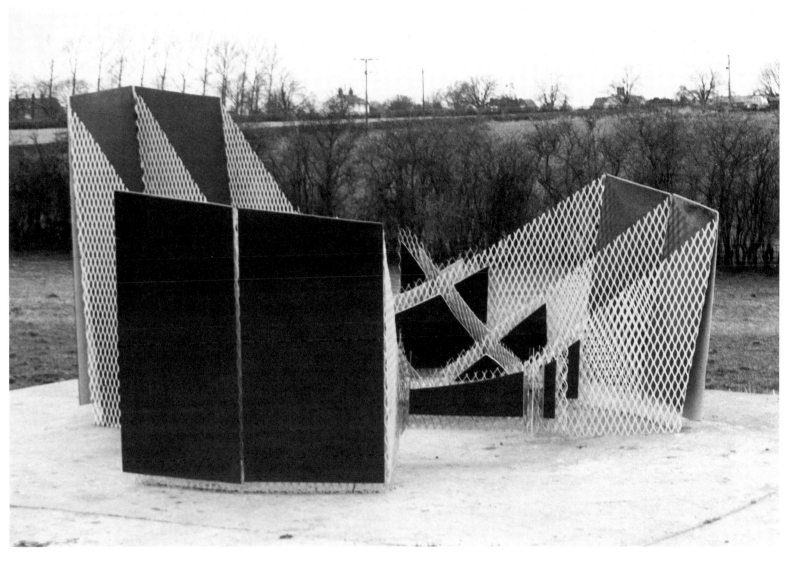

PLATE 17
Open (red blue) Bound 1974-5; steel mesh and plate, painted

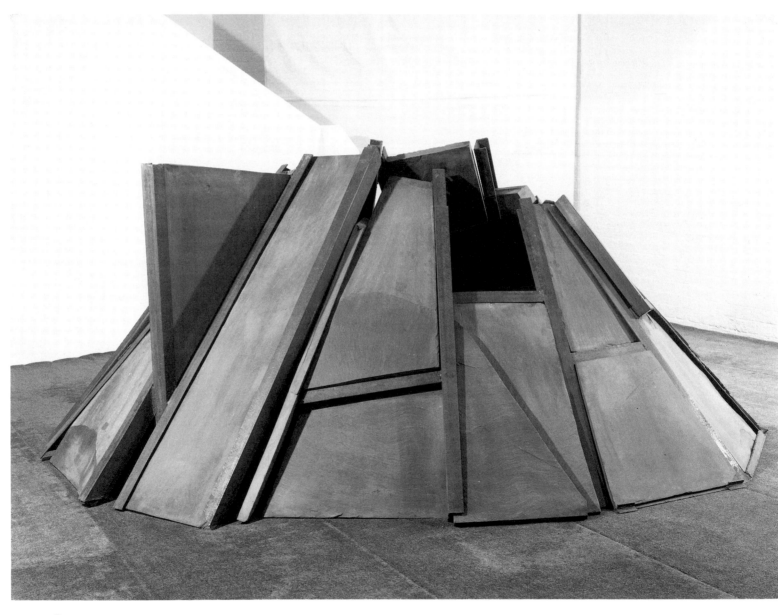

PLATE 18
Sure Place 1976-7 ; slate, steel, wood

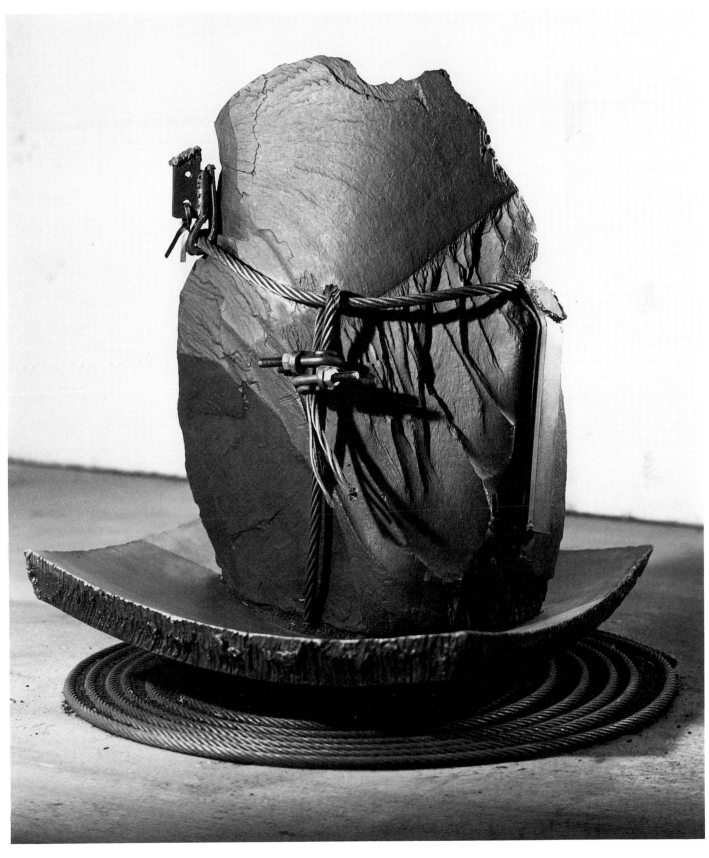

PLATE 19
Rock Place 1976-7; steel, steel cable, slate

62

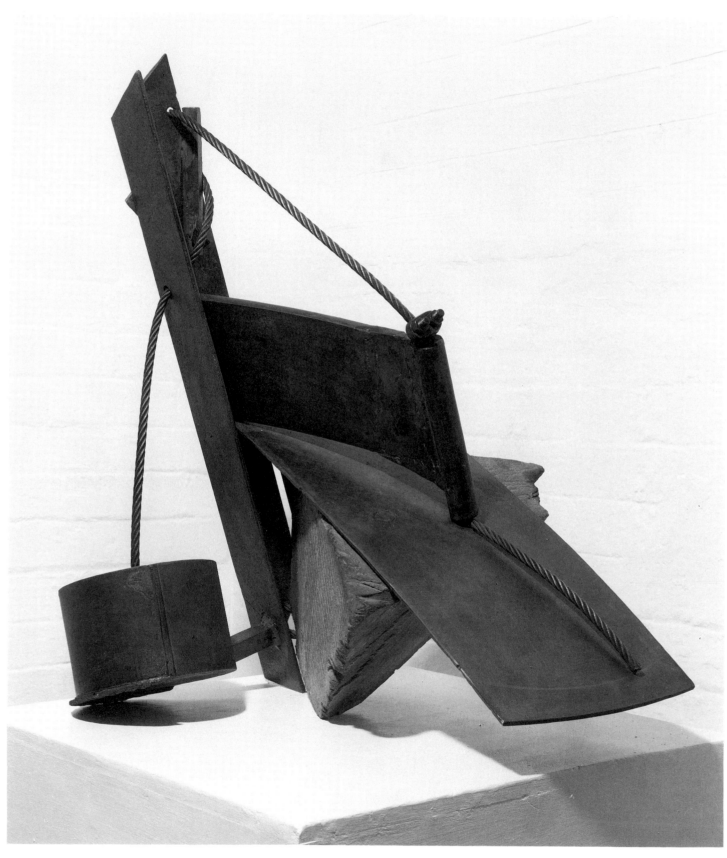

PLATE 20
Tracer 1977; steel, steel cable and slate

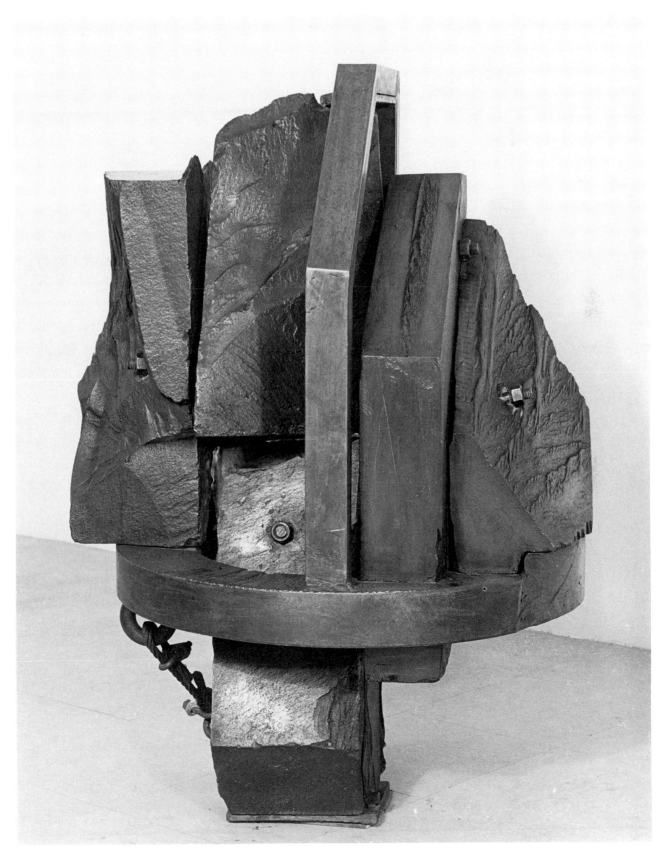

PLATE 21
Ring Rock 1978; slate, steel and lead

64

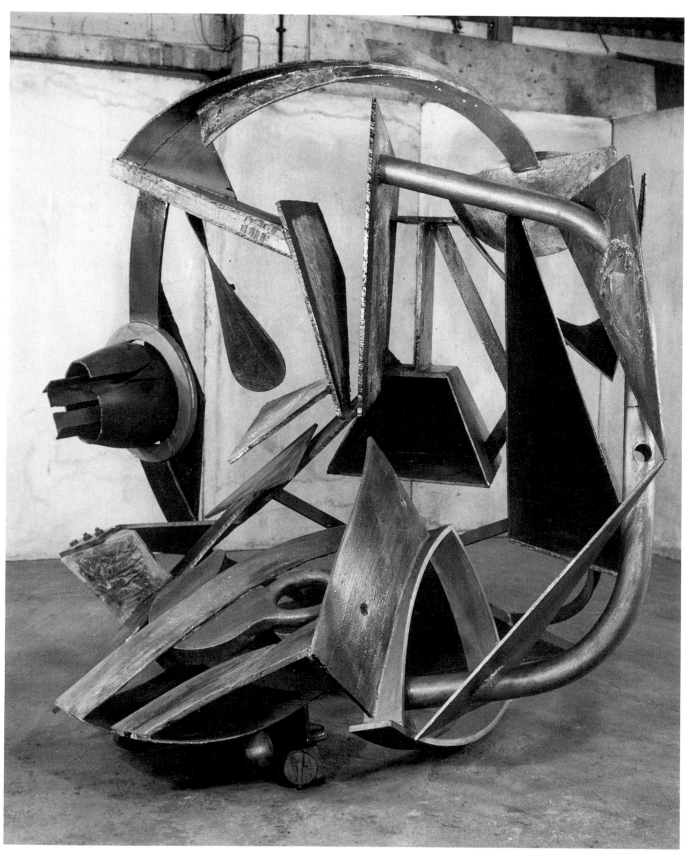

PLATE 22
Head 1982-3; steel and coloured tar

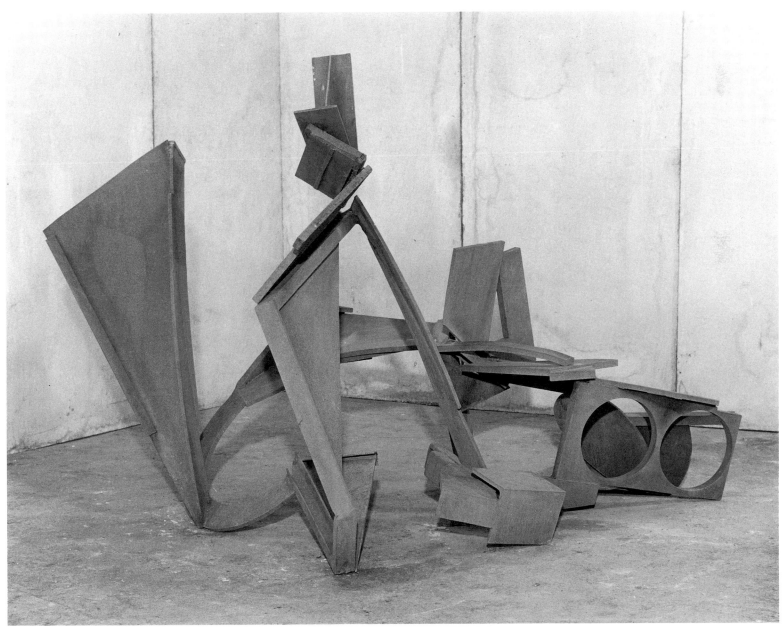

PLATE 23
Snake Rise 1979-83; steel

techniques imply the work of a man with primitive or broken tools, far in space and time from modern Japan. Material is hewn, split, splintered, joined or propped in ways that presage future falls and dislocations. *Sculpture 74* (col.pl.23; pl.13) and its companions *Brick Piece 1, 2* and *3* (ill.p.115; pls 14, 15) use an unreconstructed boulder clamped by small I-beams. This arrangement precariously supports an inverted triangle whose steel outline is filled by mesh. It is an unsettling combination of the random and the calculated.

These boulder pieces are plain but still, in their own way, virtuoso sculptures. Only King's feeling for his own techniques could have created them, and no-one else could have imagined that such disparate things might be put together. For five years King kept finding things. Sometimes they were retained for use at some unimaginable future time. On other occasions they were set to an immediate purpose. Hence the enigmatic *Rock Place* (pl.19). In large part the sculpture consists of an erratic boulder of slate that King found in Wales. It was not carved in any way. The lump of slate became a modern sculpture when King realised that he could bring it within the realm of art by adding its ties of cable, then the steel dish and cable circle. 'Found objects' always resemble art, or artists would not find them. Sometimes they can generate a more progressive invention, as happens in the case of *Shiva's Rings* (col.pl.25). This piece must have been suggested by *Rock Place*: but *Shiva's Rings*, equally made from material found in a Welsh quarry, looks back to *Quaver* (ill.p.113) and forward to the haunting sculptures of the *Fire King* series (col.pls 39, 40; pls 36, 39, 40).

In the later 1970s King made two majestic sculptures from slate. *Open Place* of 1977 (col.pl.20) (preceded by *Sure Place* (pl.18)) is an inverted cone, a tent-like structure that also suggests a solemn habitation. Although it is an architectural sculpture the abiding impression is that given by the leaning, sloping and turning movements of the slabs from which it is fashioned. In this respect it recalls *Slant* (col.pl.10), though its real forebear, in terms of presence and shifting perspective, is *Brake* (pl.6). *Open Place* is a large sculpture, and so is *Within* of 1979 (col.pl.26; ill.p.117), a construction that gives a sense of massive human effort. Perhaps this more personal atmosphere is owed to its use of wood beside the slate. Elm (following the Dutch elm disease of 1975-7) was to become increasingly important to King. As he explained at the time

I've twenty tons of elm waiting to be used. I need to work with materials I feel are beneficial – not unhealthy like fibreglass, which I found full of dust and which has a bad smell. But wood is warm and I enjoy using it.

Steel is getting very expensive now, while slate and elm are cheap. I like to use materials that are easy to get hold of so I've plenty around and I'm not restricted to something precious …[18]

King described his position as a sculptor in purely pragmatic and local terms. By 1979 he was a man of great eminence, as eminence is sometimes accounted: a CBE, an Associate of the Royal Academy, the newly appointed Professor of the Hochschule der Künste in Berlin, where he was to work for a year. Yet an artist finds true eminence only in the studio, alone. While two of King's most commanding public sculptures were erected there were interior plans in Dunstable. *Cross-bend* (col.pl.33), outside the European Patent Office in Munich and *Clarion* (col.pl.32), in West London, were sculptures that raised a hope that architects might be influenced by sculpture rather than adding sculpture as an afterthought. Meanwhile, King pursued his own ideas in *Shogun* (col.pl.28; ill.p.119), an 'architectural' sculpture that depends entirely on studio experience of materials – original ideas in slate abandoned, rotten elm wood blown out with a blow torch, refurbishments with resin and fibreglass – and points towards powerful but arcane celebrations.

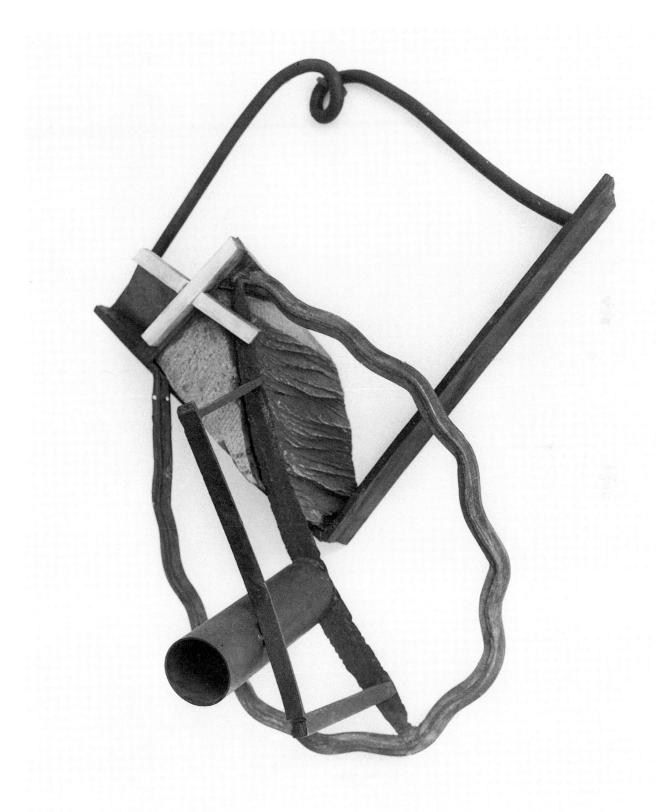

PLATE 24
Rivering Cross 1983; slate and steel, varnished and painted

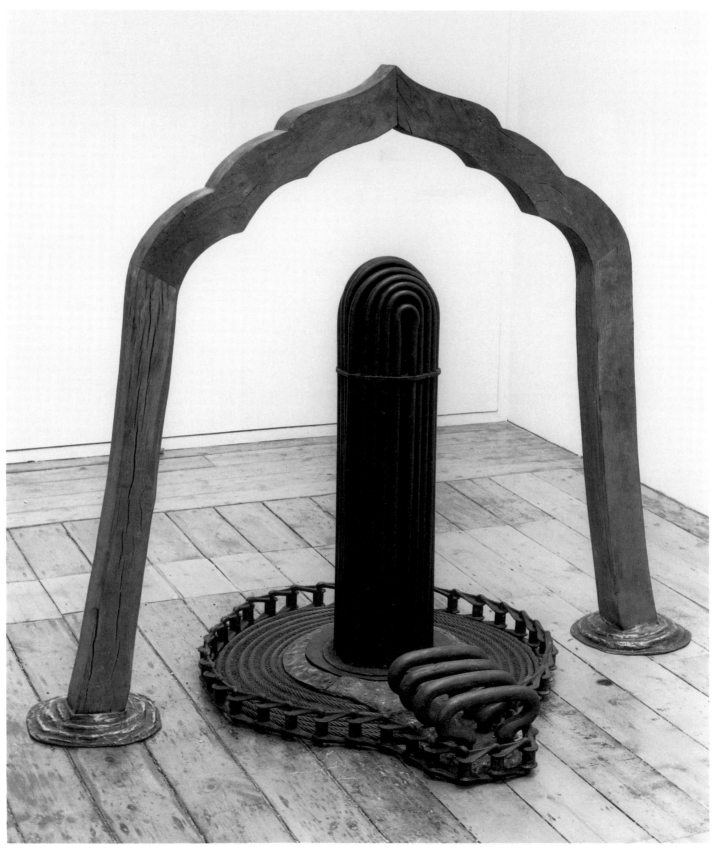

PLATE 25
Bullgate-in 1984; steel, bronze, cast iron, asphalt, wood

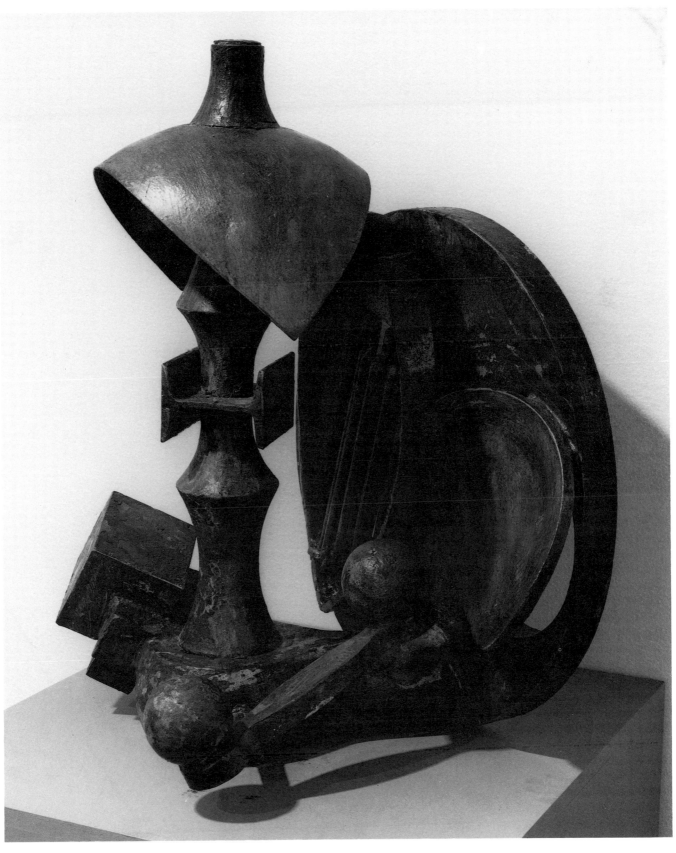

PLATE 26
Offering 1985; steel and aluminium

In 1980 King was appointed Professor of Sculpture at the Royal College of Art and in 1981 held his retrospective exhibition at the Hayward Gallery in London. A general view of two decades of work may have prompted him to consider a new start for his sculpture of the 1980s. But the Royal College of Art had a more lasting effect on the unusual, personal and finally visionary sculpture that was to follow the Hayward tribute. At the RCA King found an atmosphere in the studios that encouraged mutations in his own work. Several generations of students and many visiting lecturers came under his care. However, since the RCA is a postgraduate college its students have much independence. King found that he was observing and supporting their work, not merely supervising their expected development. He worked with many young people who were 'free-moving stylistically'. This, King believes, 'allowed me to move and change'.

King's postgraduates were often impressed by the sculpture of previous RCA students, in particular that of Richard Deacon and Tony Cragg, both of whom had left the College some years before King joined the staff. But their art had little in common with King's. His open attitude had a fairly defined goal, which was a return to figuration. For a sculptor with a background in St Martin's abstraction this might almost have been an abandonment of principle. Yet King had been a figurative sculptor for five years before he made *Drift* (pl.2) and *Declaration* (col.pl.1). Furthermore, by 1981 there was the feeling of a general return to figurative art. This was the year of 'A New Spirit in Painting', at the Royal Academy. The exhibition was notable for symbolic forms in landscape settings. In 1982 the Berlin 'Zeitgeist' exhibition had a similar tendency. The Germanic mood of current art was of course especially apparent to King after his recent stay in Berlin.

King's new work can be compared with the contemporary painting of the early 1980s. By the middle of the decade he would be making sculpture that was quite obviously concerned with symbolic figuration. Previously he had shied away from such a possibility. During the manufacture of *Red Between* (1971-3; pl.12), for instance, he cut two holes in a sheet of metal as part of an abstract design. They resembled eyes, and King thought: 'Why should I not put eyes if I want to?' The thought was still there as he produced *Head* (pl.22), after much cogitation and difficulty, in 1982-3. There was something colossal in this undertaking, as though all the grounds of King's previous sculpture were being redefined. There is even more variety in the sculpture than there had been in *Shogun*. King had broadened his terms of reference while elaborating a theme that had long been present in his work: the idea of fallen structures that once had been proudly monumental, the sensation of a fountain, a sculpture which slides, cascades and crashes, always renewed with its own waters.

Head was the major exhibit of King's Rowan Gallery exhibition in May of 1983. It was accompanied by *Spring-a-Ling* (col.pl.31), *Moonstruck* (col.pl.37) and *Rivering Cross* (pl.24), This last piece is one of King's occasional sculptures that can be hung on a wall, and the loop at the top of its higher triangle is for that purpose. *Spring-a-*

Ling is as provocative as *Rivering Cross* is demure. It is green, blue, a deep red and an orange red, all unrestrained colours in a sculpture whose central motif appears to be weighed down and compressed by the top part of the structure. One feels that a violent upwards movement would ensue if only one of the curved bars at the side of the sculpture were relaxed. This is like Baroque art, and another example of King's unusual gift for suggesting bounding motion beyond the limits of his fixed creation.

Spring-a-Ling was not the most idiosyncratic sculpture in the 1983 exhibition. It implies mechanical forces, while *Moonstruck* alludes to supernatural powers. Not in *Genghis Khan* (col.pl.3) or any previous King sculpture is there such an implication that the world is not as rational people imagine it to be. The arc at the top of the piece is, evidently, lunar, and this we would infer without assistance from the sculpture's title. When looking at King's sculptures our inferences will now be of especial importance. His most successful pieces now demand that we consider meanings beyond the norms of plain enquiry. What, for instance, should we make of the green motif in *Moonstruck*, so suggestive of the antlers of an extraordinary beast? We might think of the sculpture as embodying three parts of imaginative and earthly existence: a moon that is heavenly but not Christian; a creature that is animate but not of our world; a sculpture made from things that are found and put together, the best that man alone can do.

In the comparatively real world of the history of art, *Moonstruck*'s antlers are so reminiscent of Max Ernst that a relationship between the German and the British sculptor might be considered. Ernst, a better sculptor than a painter, was none the less underrated, even maligned, by most British abstract sculptors. King, on the other hand, probably recognised that he was among the most interesting of Surrealist artists. As always, he had interested sympathy for all sculptors who invent rather than imitate three-dimensional objects. In 1961 he had written 'To me tradition is all that I have recognised as good and relevant. I am more interested in finding broad, general principles in the art that I like than following the gradual development of only one line.'[19] This was as true of King's art in the 1980s as it had been twenty years before. Now, however, generous feelings about sculpture allowed him to fashion two sculptures that might be from different hands. *Fire in Taurus* (col.pl.38) and *Bullgate-in* (pl.25) were completed within the same twelve months in 1983-4. They are totally dissimilar, yet both are adult descendants of King's earlier interests.

Fire in Taurus is a development of *Snake Rise* (pl.23), which was begun in 1979 in Australia and reworked after its appearance in the Hayward retrospective. *Bullgate-in* has an older ancestry. It reminds us of *Genghis Khan* (col.pl.3) and *Barbarian Fruit* (pl.5). In fact its ogival wooden top is a piece of wood that had been in King's possession since 1962. The two legs of the sculpture stand in puddles of bronze, and this is King's first use of bronze; though not of the steel rope, asphalt and black tar, for these materials first appeared in *Rock Place* of 1976-7 (pl.19), *Bullgate-in* has an implacable and funereal air and in fact was made while King was thinking of a

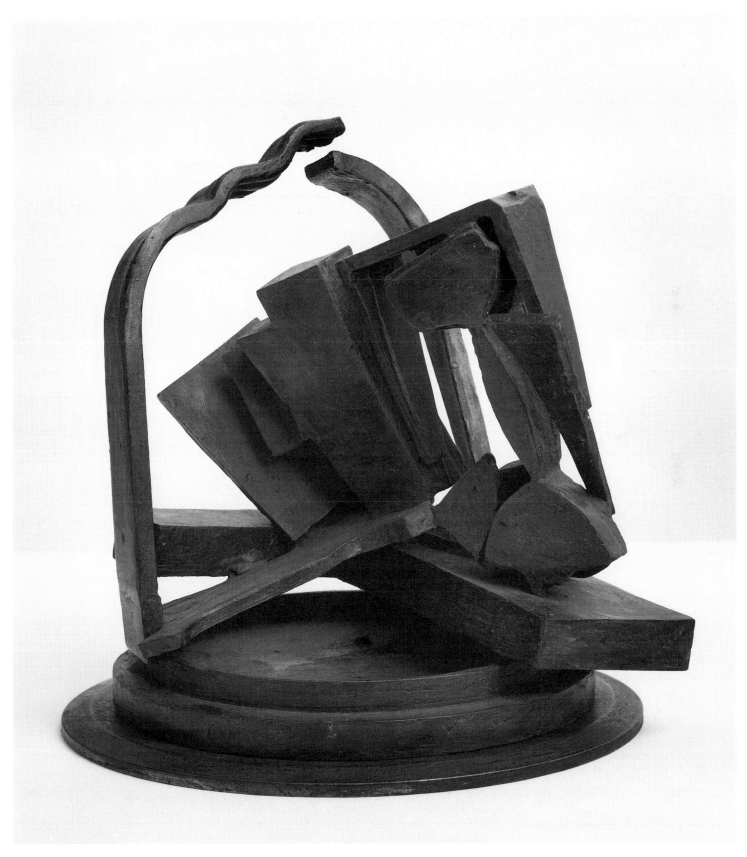

PLATE 27
Small Bronze Piece 1986; bronze

memorial sculpture, later abandoned. The titles of these two sculptures are relevant, for they refer to King's own birth sign. The Taurean sculptor, King implies, can create freely in life; and yet there are terrible things in a sculptor's life that are preordained, fixed as iron fate. One such fate is indicated by the dedication of this book.

Between 1984 and 1986, to give rough dates, we find King preoccupied with new materials and with projects for monuments. He had never loved steel for its own sake, was always ready to experiment with other ways of manufacturing and felt that a different stuff or substance might come beneath his hands. *Shadow Player* (1985-6, ill.p.119) is of steel and asphalt, *Judy's Butterfly* (1985; col.pl.34; ill.p.119) of steel and aluminium. While working on *Offering* (pl.26) in this year (it is an unresolved funeral piece) and some maquettes for a Hiroshima monument King found a material called 'Oasis'. This is a kind of foam, much used in shop fitting and flower arrangement. It took King two years to accustom himself to Oasis but he persevered because of its evident advantages. It is malleable, so both hands and tools find an activity somewhere between carving and modelling, and wax easily soaks into it. King especially liked to cut the foam: this reminded him of an old fascination with making incisions in soft substances. Mistakes in Oasis were correctable. It gave scope for improvisation, yet any sculpture made in King's new way could be cast in bronze. From late 1986 this is the material that carries King's vision – the mixture of monument, autobiography, fantasy and Taurean myth that gives birth to this latest work.

The appropriate introduction to this vision is *Sun, Bird, Worm, House* (1986-90; col.pl.35), a piece that proclaims that sculpture can do anything. First of all it shows something never sculpted except on relief panels, the sun. This sun is brought to earth, for the dozen poles we take to be its rays are in literal fact its support. These rays do not diffuse the sun's light and energy so much as they gather and direct its radiance, as though through a magnifying glass. The worm we guess to be a sea slug. At the lower end of the see-saw is a sombre human figure. At its other extremity is an upside-down parrot. The house is also upside down: we take it that the tip of its roof rests on the ground. All these things appear the more primitive and unmeditated because the sculpture's craftsmanship is deliberately rough. We are at some distance from the fine art of museums. *Sun, Bird, Worm, House* is like an exemplification of some other continent's bizarre folk culture, full of baffling proverbs and inexplicable rituals.

The sculptures here called (without the artist's authority) the Mediterranean trilogy are by contrast classical and allegorical. They are *It's a Swell Day for Stormy Petrels* (col.pl.41), *The Mirror, the Bean and the Aqueduct* (col.pl.42) and *Where is Apollo Now?* (col.pl.43). The *Petrel* sculpture is dated 1989 and was the first to be made. Its two companions are of 1989-90 but were conceived in their general form at the outset of the whole enterprise. *Petrels* was begun by constructing the aqueduct and the obelisk. Then King made the flat triangular part of the work, crouching to fashion

waves and birds with his hands. One part of this triangle represents land. The anchor or scythe element is embedded into this land and left there, like an axe remaining in the wound it has caused to wood.

King describes these recent sculptures as 'using my earlier stuff in symbolic form' in 'a dialogue with my earlier self, a commentary on what I was doing before.' Such observations help to relate the first two sculptures of the trilogy to the environmental pieces of 1966-8, *Span, Call* and *Blue Blaze* (col.pls 8, 14, 16), for one might scarcely recognise that the earlier and the later sculptures came from the same mind and hand. The *Bean* sculpture is particularly reminiscent of pictorial Surrealism of the 1930s. We think of Magritte and of Picasso's beach scenes. This is not however an illusionistic work, though it may appear so in photography. The relative sizes of these architectural and human metaphors obey purely sculptural logic. There is still magic in the logic. The three pieces of *Bean* make the floor into the sea. One experiences the sculpture, therefore, as though walking on water. The fluid element has become material. The marvellous is made concrete.

The most peculiar of these three works is *Where is Apollo Now?* It is especially challenging because most of it is deliberately bad painting rather than sculpture. We trace its history from a previous piece called *Heart* (1988; pl.29), made with foam. This small work was enlarged into a heart six feet high, and started to become a sculpture with a column and a vegetable form like that in its maquette. Then there was fire in King's Dunstable studio. It smouldered all night. Then flames destroyed all his foam work and much besides. His next scheduled exhibition was impossible. Later, King rescued the column that belonged to *Heart*. He put it up against the wall and began the sculpture we now know.

King's fire had added another element to the Earth, Air and Water that had already been considered in his sculpture. *Where is Apollo Now?* must contain many meanings private to King himself. It also has a source in a more common mythology. King had been reading J.G. Frazer's *The Golden Bough* (1890-1915) and in this anthropological analysis of ancient myth had been struck by three or four stories. The most relevant of them is that of Attis, the beautiful shepherd boy loved by the Phrygian goddess Cybele. Frazer recounts the violent and barbaric rites of her votaries. In their cult Attis was worshipped in the form of a cone, for he had been changed into a fir tree as punishment for the temptation of a goddess. Reading Frazer's book in civilised North London, King's interest was aroused, and then his memory. Could his lifelong interest in cones have come from those pine remnants of the cult of Attis that he had seen in a Carthage museum, when he was a child?

No-one can tell. But it now seems important that King, through the accident of his birth and upbringing – only the gods know what an accident is – may be reckoned one of the few sculptors for whom the ruins of the classical pre-Christian world remain a living and potent force: dionysian, cruel, ecstatic, sometimes noble, always inexplicable. We believe this by looking at his art. But why is it that King's personal classicism is most apparent in *Where is Apollo Now?* So much of this sculpture feeds on things we know to be banal,

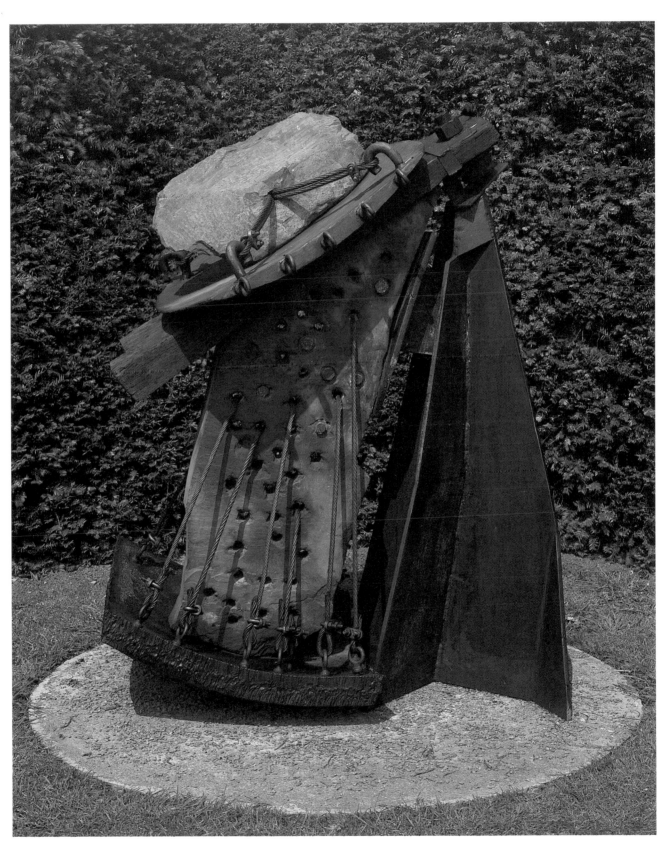

COLOUR PLATE 25
Shiva's Rings 1978; steel, steel cable, slate, wood

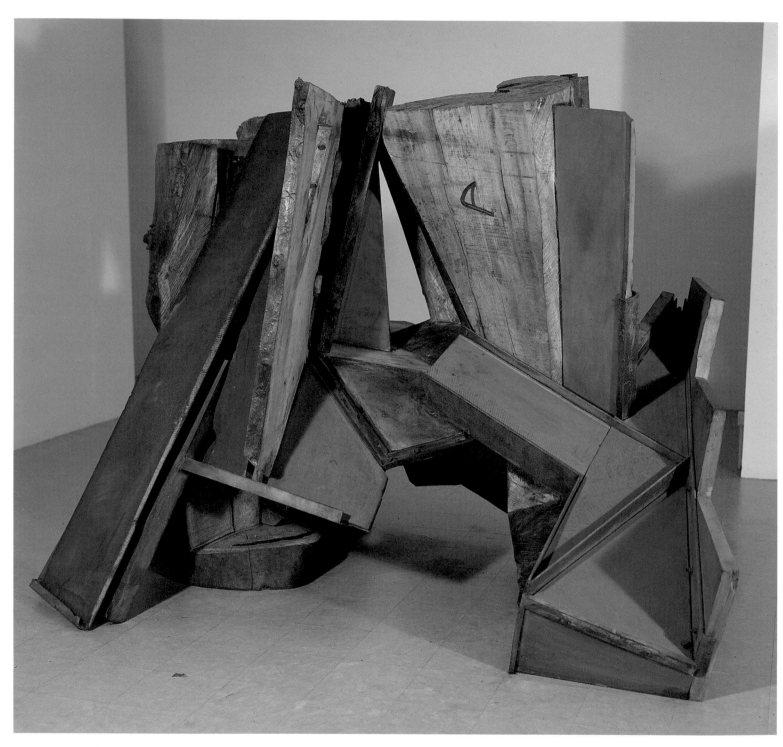

COLOUR PLATE 26
Within 1979; slate, steel, and elm

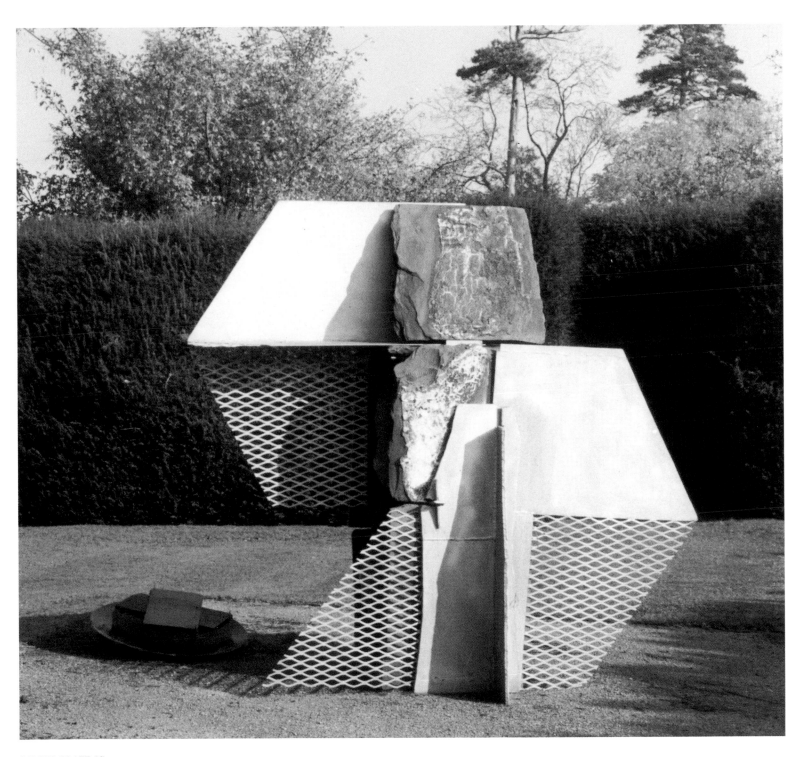

COLOUR PLATE 27
Sculpture '75 (O Place) 1975; zinc-sprayed steel, Welsh slate, wood, cord and coloured tar

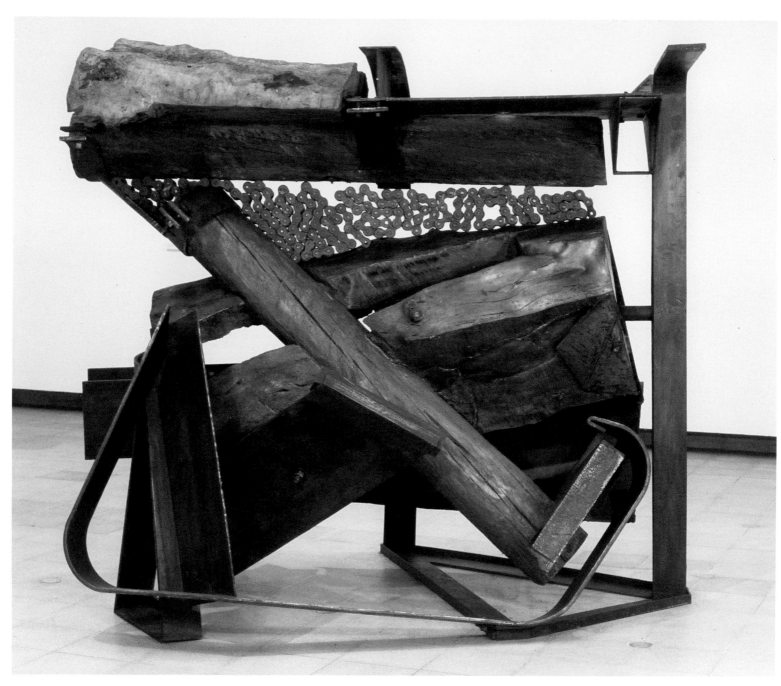

COLOUR PLATE 28
Shogun 1981; wood, steel and chain resin

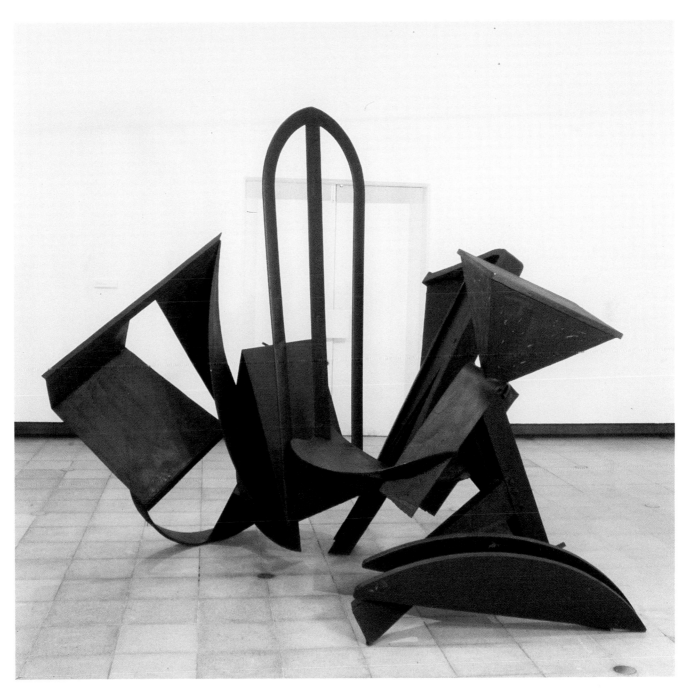

COLOUR PLATE 29
L'Ogivale 1981 ; steel

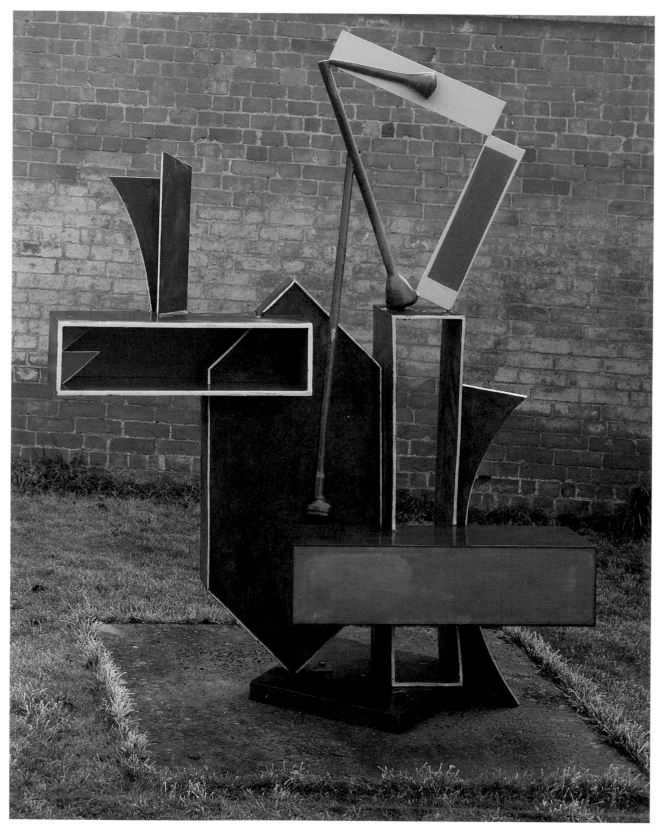

COLOUR PLATE 30
Cavalcade 1986; steel

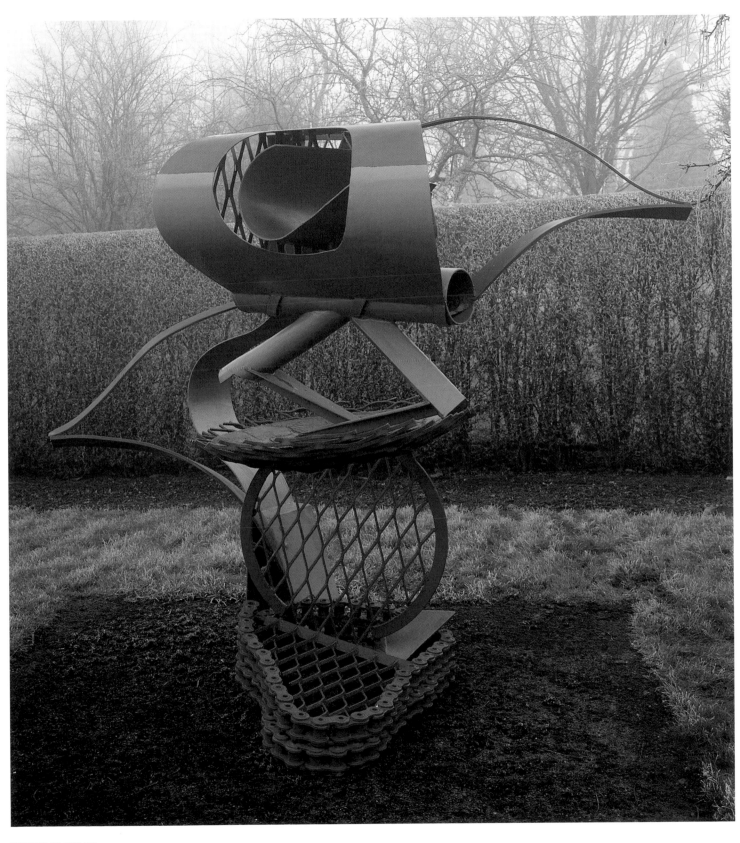

COLOUR PLATE 31
Spring-a-Ling 1983; steelplate, mesh, steel cable and chain

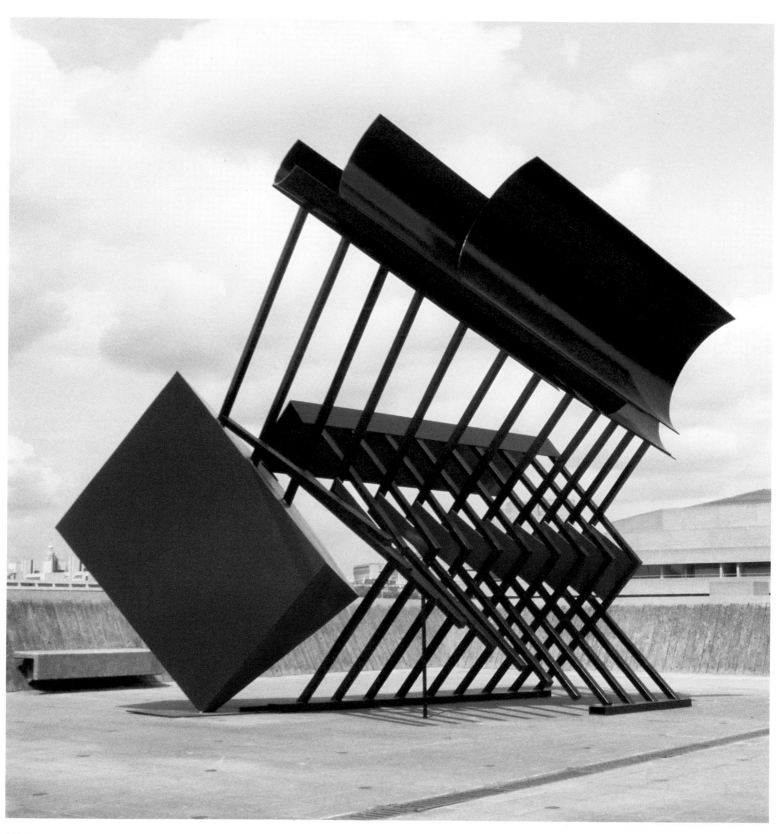

COLOUR PLATE 32
Clarion 1981; steel

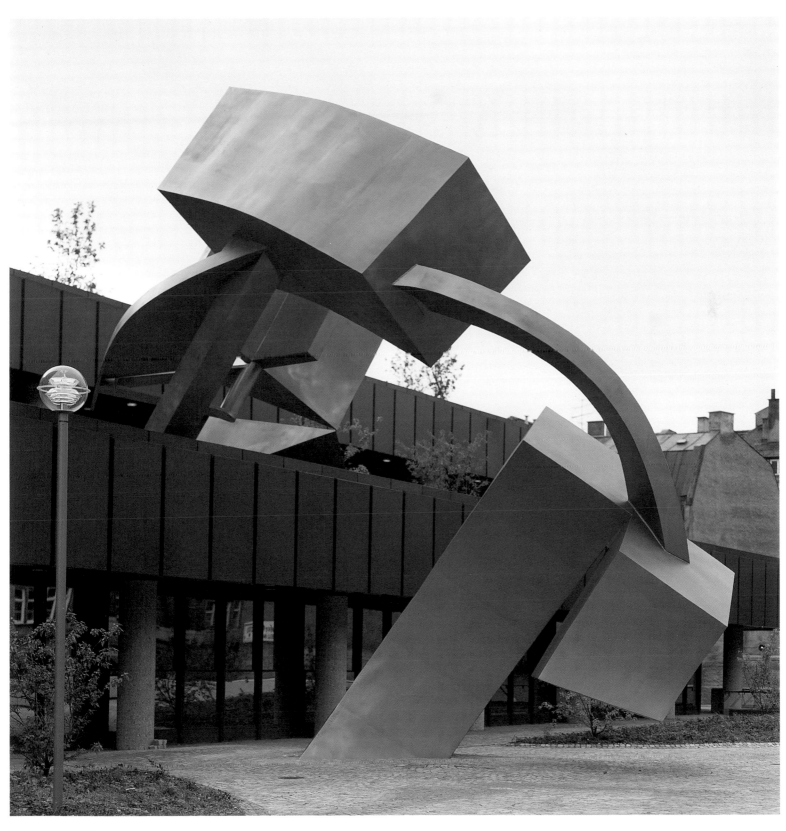

COLOUR PLATE 33
Cross-bend 1978-80; steel

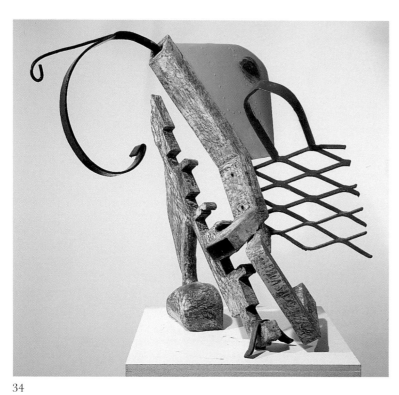

34

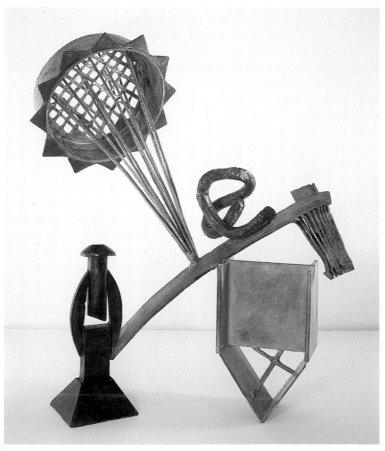

35

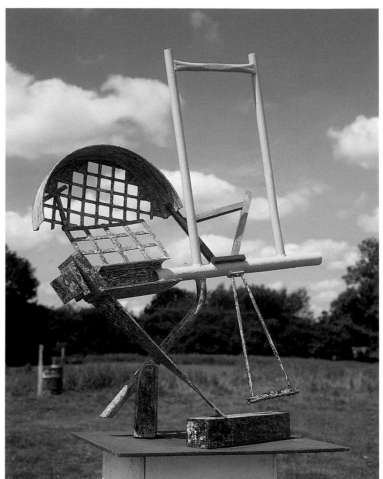

36

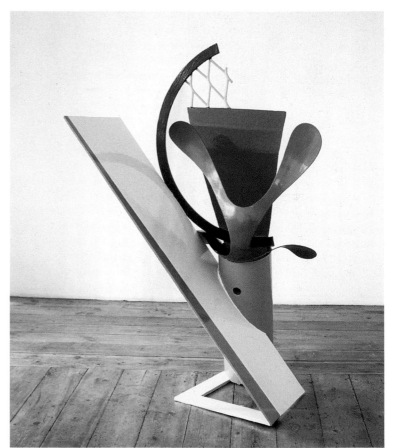

37

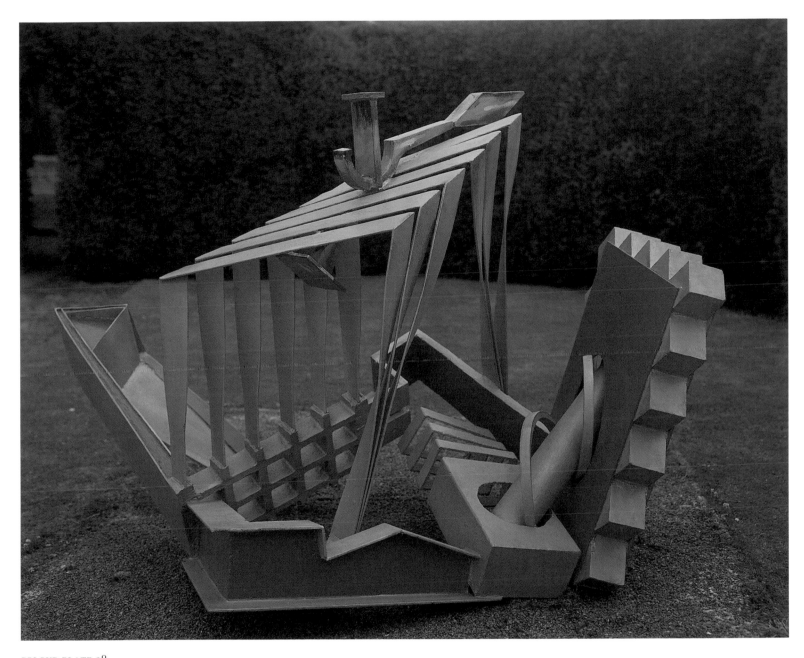

COLOUR PLATE 38
Fire in Taurus 1984; painted steel

COLOUR PLATE 34
Judy's Butterfly 1985; steel and aluminium, painted

COLOUR PLATE 35
Sun, Bird, Worm, House 1986-90; bronze

COLOUR PLATE 36
Yellow Trapeze 1986; steel

COLOUR PLATE 37
Moonstruck 1983; painted steel

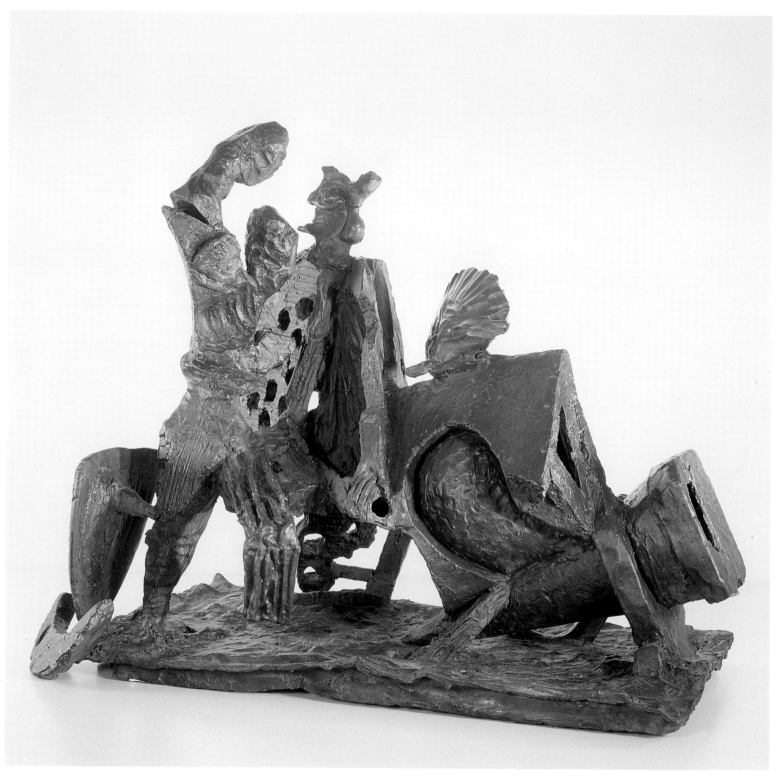

COLOUR PLATE 39
Fire King No.1 1989-90; bronze

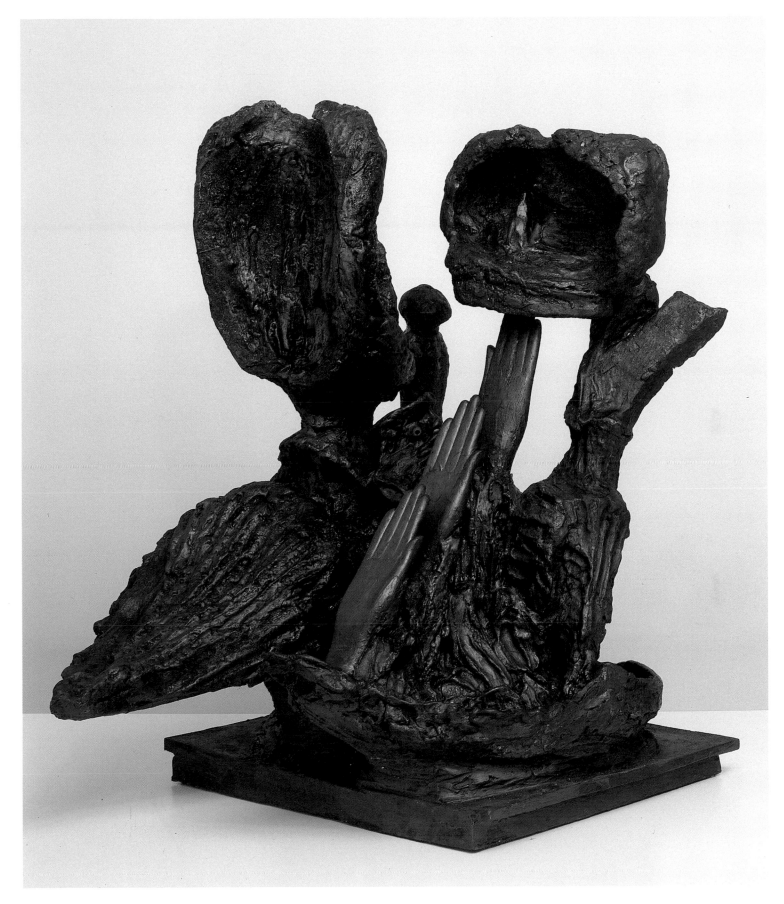

COLOUR PLATE 40
Fire King No.4, Water Hands 1991 ; wax for bronze

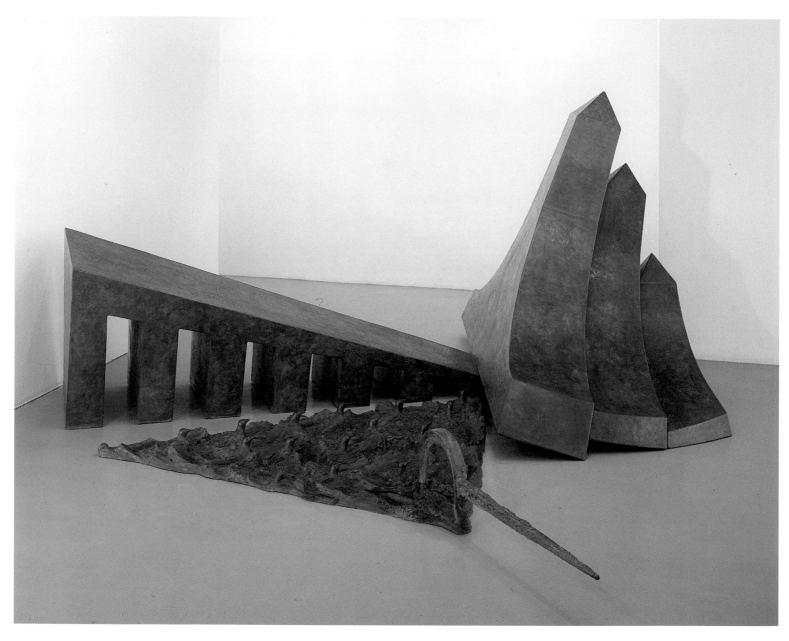

COLOUR PLATE 41
It's a Swell Day for Stormy Petrels 1989; fibreglass for bronze

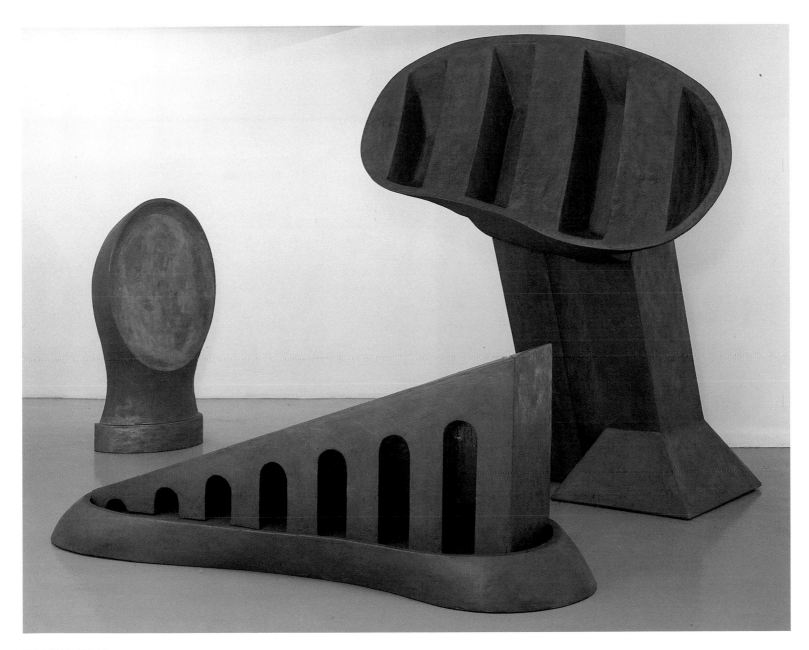

The Mirror, the Bean and the Aqueduct 1989-90; fibreglass for bronze

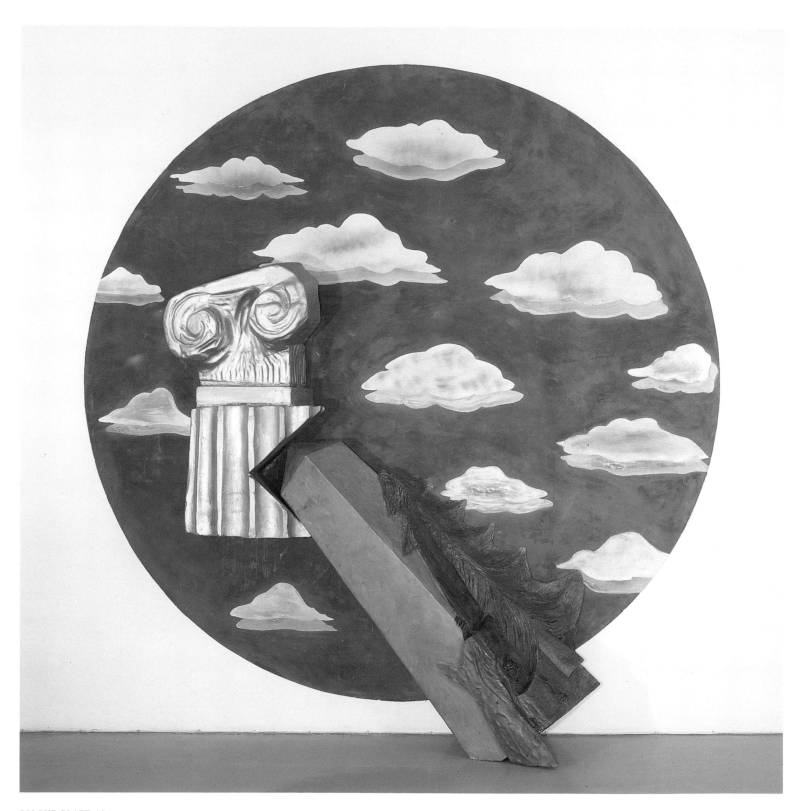

COLOUR PLATE 43
Where is Apollo Now? 1989-90; fibreglass, epoxy resin, acrylic paint

L
L

tawdry, second-hand. Yet the sculpture would not be so moving if the fibreglass circle and column were better painted. In fact the style of this painting was carefully calculated. King thought of making a similar piece but decided against the project. 'You can never approach kitsch more than once.'

It is indeed a solitary and peerless sculpture. *Where is Apollo Now?* belongs to the style and the period of post-modernism but transcends this period style. It is like an unrepeatable gift to the junior and immature sculptors who were his friends and students. King's imagination now looked to his interior life. The detail of the dead youth, the fish and the pine tree gives an indication of the way that Oasis foam might be used. Such handling, to use the painters' term, is seen to even greater effect in the group of four sculptures begun at the time of the Mediterranean trilogy and concluded at the end of 1991. The first of them is *Fire King* (col.pl.39). The second is a reworking of *Fire King* and is called (from a line in a haiku) *Plop, the Frog Jumps* (pl.36). The third sculpture is entitled *The Other* (pl.39) and the fourth is *Water Hands* (col.pl.40). The four sculptures could not have been made in clay or plaster, and the physical newness of his material liberated an impulse in King. It was not programmatic so much as autobiographical.

As work on the sculptures progressed King began to associate them with the four elements. We are at liberty to think of them as evocations or portrayals of Fire, Earth, Air and Water. The earthly King loses life in the water, is pursued by fire and aspires to the air. But this would be only a part of the sculptures' iconography. They are loaded with further meanings. In *Fire King* there is a head in a pillow, a shell that might also be a head and a vase that represents

a genie let out of a bottle. At the centre of the sculpture is the king, a figure strikingly reminiscent of the head of Christ that King had made when a student at Cambridge. In each of the four sculptures this king is a surprised onlooker, but he is also both protector and judge. In *Fire King* he holds back the threatening figure from the dreamer. In *Plop, the Frog Jumps* something else happens. King was thinking of an Egyptian mother goddess, and his central figure becomes hermaphroditic. The frog jumps from the king's belly. This sculpture has the head of a youth attached to the body of a sea snake. The holes in its fabric are the holes in a skull. Moons and shields were afterthoughts 'but helped the mood of the work'.

It is not possible to consider these sculptures without being disturbed. Their dark, lyric mood, the themes of life and death, are quite apparent even if one has little inkling of their themes. We are disturbed for the better. With *Fire King* and its progeny in mind one begins to think of all King's sculpture as a preparation for the original elegies that will appear in the last years of our century, some of them without a doubt from King's own studio. In 1992 he seems immeasurably changed from the young man who began to become a sculptor. Yet the fact that his latest work draws on his earliest suggests that nothing is lost in King's sculptural life. In four decades so much changes in art and human circumstances, while things made as art do not lose their validity. To quote Hannah Arendt again, from the book King read as a young man, 'a premonition of immortality, not the immortality of the soul or of life, but of something immortal achieved by mortal hands, has become tangibly present'.[20]

Notes

1. Anthony Caro, notes for a lecture, unpublished manuscript, late 1970s, quoted in Tim Hilton, *Anthony Caro*, Serpentine Gallery, 1984, p.60.

2. 'Trip to Greece', manuscript, quoted in Rudolf Oxenaar, *Phillip King*, Rijksmuseum Kröller-Müller, Otterlo, The Netherlands, 1974, p.13.

3. Richard Morphet, 'William Tucker', in *The Alistair McAlpine Gift*, Tate Gallery, 1971, p.91.

4. Norbert Lynton, 'Latest Developments in British Sculpture', *Art and Literature*, No.2, 1964.

5. Quoted by Tucker in 'Confessions of a Formalist', a lecture given at St Martin's and subsequently revised for the *New Review*, Vol.3, No.27, 1975.

6. King's writing and statements are collected in Oxenaar, *op.cit*, 1974.

7. As reported by Lynne Cooke, *Phillip King*, Hayward Gallery, 1981, p.38.

8. King, interview with John Coplans, *Studio International*, December 1965, pp.254-5.

9. For this group see Tim Hilton, *Jules Olitski*, Salander O'Reilly Gallery, New York, 1990.

10. 'Phillip King talks about his sculpture', *Studio International*, June 1968.

11. *Ibid.*

12. See Roger Berthoud, *The Life of Henry Moore*, London, 1987, p.281.

13. Charles Harrison, 'Phillip King, Sculpture 1960-68', *Artforum*, New York, December 1968. A view later repudicated: see Harrison, 'What Kind of Discourse?', *ARTmonthly*, June 1981. King's reply in the same issue contains valuable information about technical procedures.

14. Bryan Robertson, *Phillip King*, Whitechapel Art Gallery, London, 1968, unpaginated.

15. See Margaret Garlake, 'The Contemporary Art Society in the sixties and seventies', in *British Contemporary Art 1910-1990*, London, 1991, p.iii.

16. King, interview with Lynne Cooke, published in Cooke, *op.cit*, 1981, p.72.

17. Norbert Lynton, *Sculptures by Phillip King*, Arts Council of Great Britain, 1975, unpaginated.

18. Unsigned review of King's exhibition at the Rowan Gallery, 1979, *Hampstead and Highgate Express*, 6 April 1979, quoted in Cooke, *op.cit*, 1981, p.72.

19. King, statement in *First, An Occasional Magazine*, No.2, the sculpture department of the St Martin's School of Art, London, 1961, quoted in Oxenaar, *op.cit*, 1974, p.18.

20. Arendt, as quoted in Lynton, *op.cit*, 1975 and Tucker, *op.cit*, 1975.

Biography

Compiled with notes contributed by the artist

1934	Born Kheredine, near Carthage, Tunis
1946	Came to England
1947-52	Mill Hill School, London
1952-4	National Service, Royal Corps of Signals
1953-4	Spent a year in Paris. Made drawings from sculpture in the Louvre
1954-7	Studied Modern Languages at Christ's College, Cambridge
1955-7	Made sculpture while at Cambridge. Influences: Picasso, Matisse, Laurens, Maillol
1957	Married Lilian Odelle. Divorced 1986
1957-8	Studied sculpture at St Martin's School of Art, London, because Caro was teaching there. Made small sculpture in clay and plaster of a Brutalist/Surrealist type
1959-78	Taught at St Martin's School of Art, London
1959-60	Assistant to Henry Moore. Gained confidence in working on a larger scale
1960	Awarded Boise Scholarship and travelled to Greece. Cleared studio and started a series of drawings from which *Window Piece* and *Declaration* were made
1962	Started using fibreglass and colour with *Rosebud*
1964	Taught for one term at Bennington College, Vermont, USA. Encouraged by David Smith to work in steel
1965	Son Antony born. First steel sculpture
1967-8	Taught at the Slade School of Fine Art, London
1967-9	Trustee of the Tate Gallery, London
1968	Represented Britain with Bridget Riley at the Venice Biennale
1969	First Prize at the Bratislava International Sculpture Exhibition, Czechoslovakia
1969	Set up studio at Clay Hall Farm, near Dunstable. Started to equip the new studio for working in steel. Travelled to Japan for three months, and completed *Sky* there in steel for Expo '70
1972	Built studio in the garden of his house in London
1974	Received CBE
1975	First slate works
1977	Elected Associate of the Royal Academy
1979-80	Professor of Sculpture at the Hochschule der Künste, Berlin
1980-90	Professor of Sculpture at the Royal College of Art, London
1984	Son Antony killed in an accident. Began living with Judy Corbalis whom he married in 1991
1989	Return to figurative sculptures, also carries on with abstract themes
1990-	Professor of Sculpture at the Royal Academy Schools, London. Elected Royal Academician. Made Professor Emeritus at the Royal College of Art, London. Works full time at Dunstable studio
1992	Sets up small studio in London

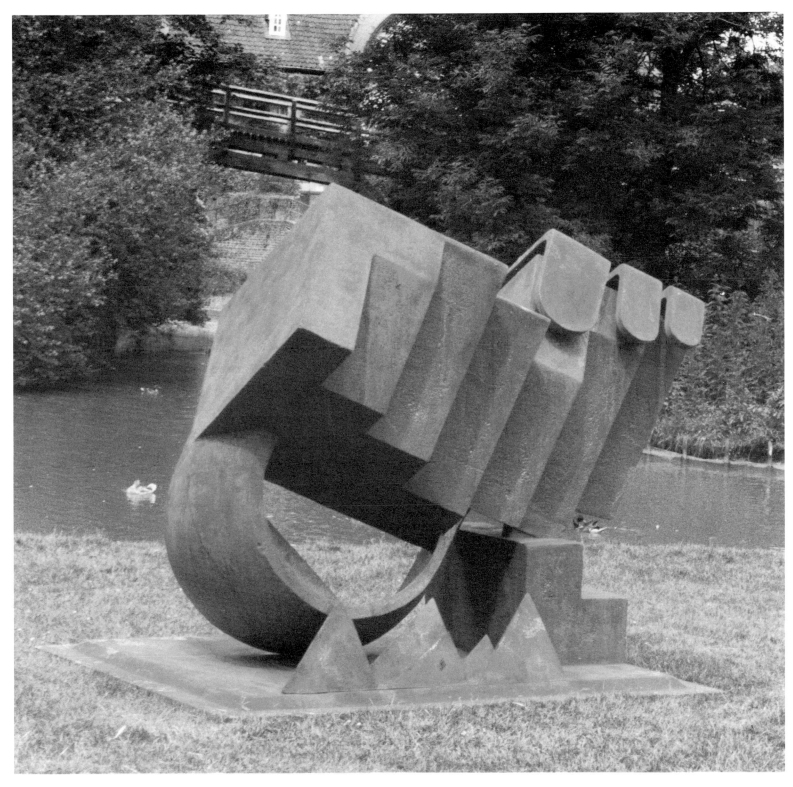

PLATE 28
Peaks and Chimes 1987; cast iron

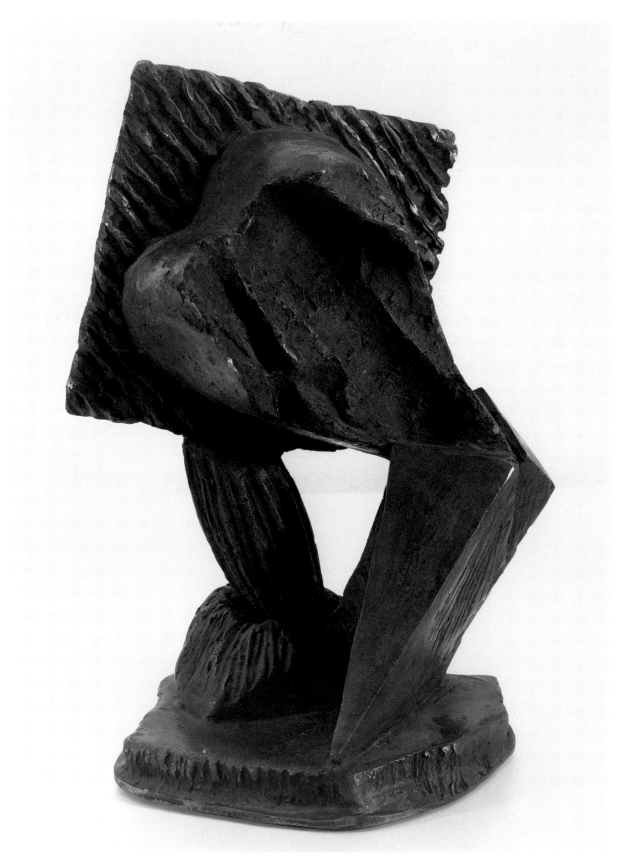

PLATE 29
Heart 1988; bronze

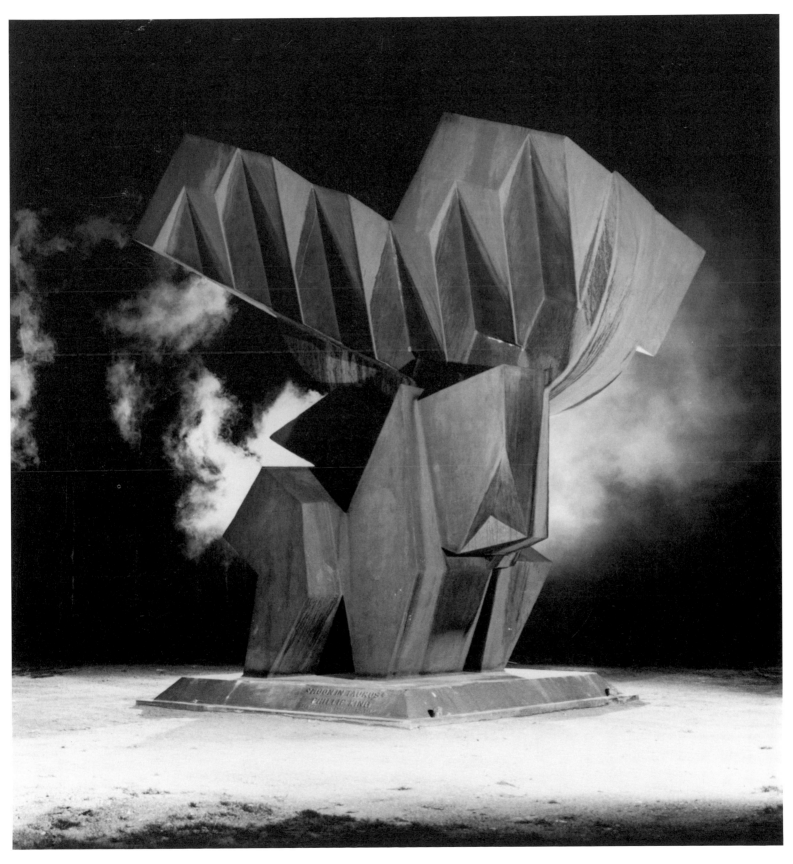

PLATE 30
Moon in Taurus 1987; cast steel

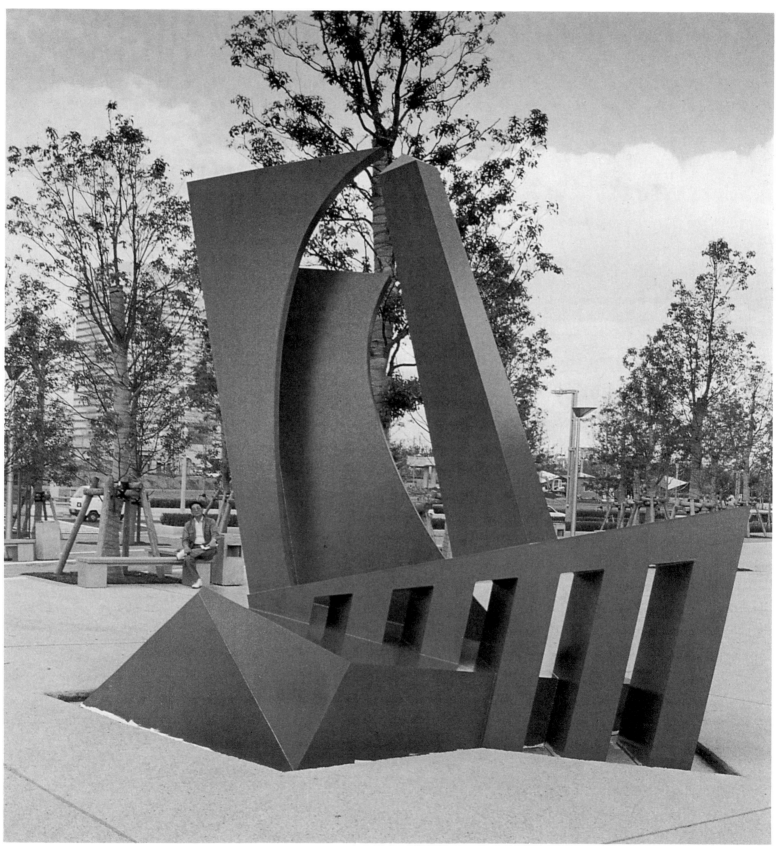

PLATE 31
Sculpture for Chiba City 1989; steel

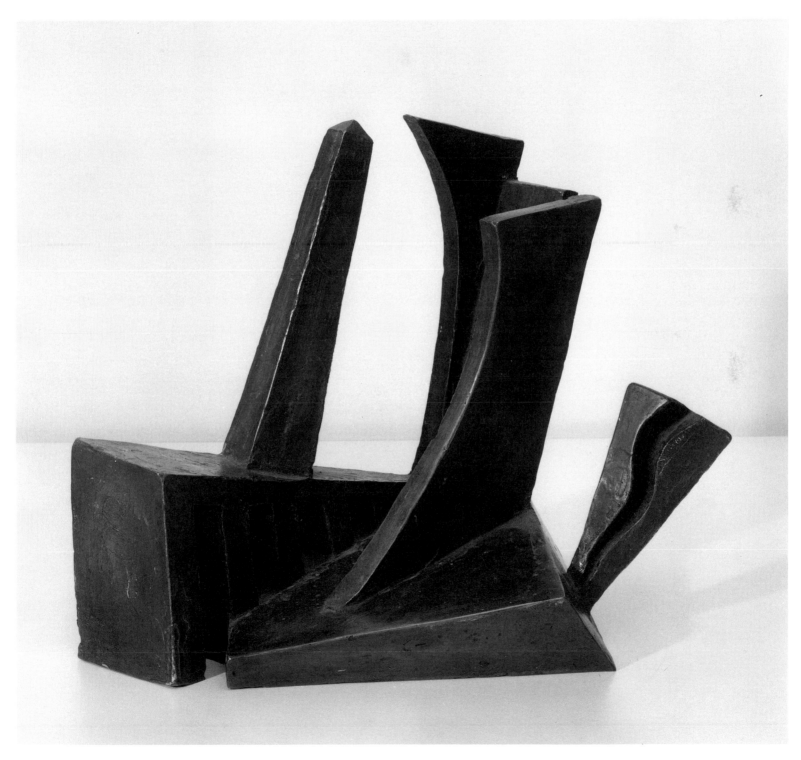

PLATE 32
Twilight Obelisk 1989; bronze

Solo Exhibitions

1957 Heffers Gallery, Cambridge (whilst a student)
1964 Rowan Gallery, London
1966 Richard Feigen Gallery, New York
 Isaac Delgado Museum of Art, New Orleans
 Richard Feigen Gallery, Chicago
1968 Galerie Yvon Lambert, Paris
 Whitechapel Art Gallery, London
 British Pavilion, Venice Biennale (with Bridget Riley)
 Stadt Galerie, Bochum
 Museum Boymans van Beuningen, Rotterdam
1970 Rowan Gallery, London
1972 Rowan Gallery, London
1973 Rowan Gallery, London
1974-5 European Tour: Rijksmuseum Kröller-Müller, Otterlo;
 Kunsthalle Düsseldorf; Kunsthalle Bern; Musée Galliera, Paris;
 Ulster Museum, Belfast
1975 Rowan Gallery, London
1975-6 Arts Council Tour: Mapping Art Gallery, Sheffield; Whitehaven
 Museum, Cumbria; Art Gallery & Museum, Aberdeen; Third
 Eye Centre, Glasgow
 Arts Council Tour: Hatton Gallery, University of Newcastle;
 Museum & Art Gallery, Portsmouth
1976 Oriel, Welsh Arts Council, Cardiff
1977 Rowan Gallery, London
1979 Rowan Gallery, London
1981 Hayward Gallery, London
 Fruit Market Gallery, Edinburgh
1983 Juda Rowan Gallery, London
1987 Nishimura Gallery, Tokyo
1990 Mayor Rowan Gallery, London
 Grob Gallery, London
1992 Yorkshire Sculpture Park
 Städtische Kunsthalle, Mannheim
 Art Warehouse, London

Group Exhibitions

1961 'British Sculpture', Jewish Museum, New York
 'British Sculpture', Madrid & Bilbao
1963 Third International Biennale des Jeunes Artistes, Paris
1964 'New Realists', The Hague & Düsseldorf
 Documenta III, Kassel, Germany
1965 'English Eye', Marlborough-Gerson, New York
 'The New Generation', Whitechapel Art Gallery, London
 'London: The New Scene', Walker Art Center, Minneapolis and
 touring USA
1966 'Primary Structures', Jewish Museum, New York
 Galleria Notizie, Turin
 Galleria dell'Ariete, Milan
 'British Sculpture', Galerie Friedrich Dahlem, Munich
 'Sculpture in the Open Air', Battersea, London
 Sonsbeek '49, Arnhem, Holland
 'Chromatic Sculpture', Arts Council Touring Exhibition
 'New Shapes of Colour', Stedelijk Museum Amsterdam,
 Kunstverein Stuttgart & Kunsthalle Bern
 'Young British Sculptors', Kunsthalle Bern, Stedelijk Museum,
 Amsterdam, & Kunstverein Düsseldorf
1967 'Art for the City', Institute of Contemporary Art, Philadelphia
 'Monuments, Tombstones & Trophies', Museum of Contemporary
 Crafts, New York
 Pittsburgh International, Carnegie Institute, Pittsburgh,
 Pennsylvania
 Fifth Guggenheim International Exhibition, New York
 'A Tribute to Robert Fraser', Robert Fraser Gallery, London
 London Group Exhibition, Rowan Gallery, London
1968 Leicestershire Education Authority Collection, Part I
 'Interim Exhibition', Whitechapel Art Gallery, London
 Documenta IV, Kassel, Germany
 'Young British Generation', Akademie der Künste, Berlin
1969 'Arts '69', Art Museum of Ateneum, Helsinki
 'Contemporary Art – Dialogue between East and West', National
 Museum of Modern Art, Tokyo
 'The Constructive Heritage', Sonja Henie and Niels Onstad
 Foundation, Blommenholm, Norway
 'Tenth Biennale for Sculpture', Middelheim, Antwerp
 'Post 1945 Art', CALA Arts Centre, Cambridge
 'Socha Piestanskych Parkov 1969', Czechoslovakia
 'International Sculptors', Symposium for Expo '70', Osaka, Japan
1970 'Some Recent Art in Britain', Leeds City Art Gallery
 'British Sculpture Out of the Sixties', ICA, London
 'La Sculpture dans La Cité', Reims
 'Contemporary British Art', National Museum of Modern Art,
 Tokyo
1971 Summer Season, Rijksmuseum Kröller-Müller, Otterlo, The
 Netherlands
 'British Painting and Sculpture 1960-70', National Gallery,
 Washington, DC
 'McAlpine Gift Exhibition', Tate Gallery, London
1972 'British Sculpture '72', Royal Academy, London
1973 'Magic and Strong Medicine', Walker Art Gallery, Liverpool,
 selected by Norbert Lynton
 'From Henry Moore to Gilbert & George – Modern British Art
 from the Tate Gallery', Palais des Beaux-Arts, Brussels

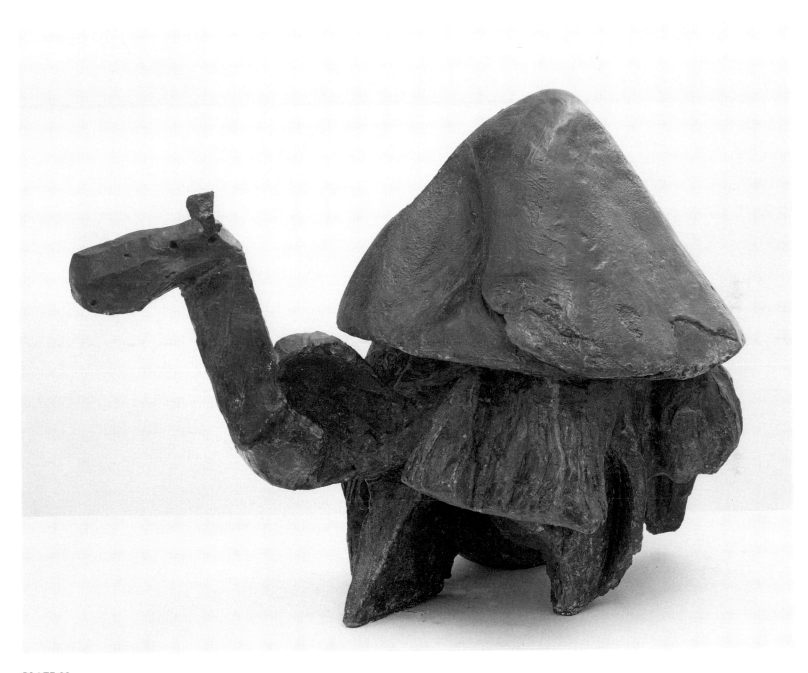

PLATE 33
Ubu's Camel 1989; bronze

98

1975 CAS Art Fair, Mall Galleries, London
'The Condition of Sculpture', Hayward Gallery, London
'British Exhibition, Art 6 '75, Basel', Schweizer Mustermesse, Basel
1976 'Contemporary British Art', Galleries of the Cleveland Institute of Art
'Arte Inglese Oggi', Palazzo Reale, Milan
Faculty Exhibition, Chelsea School of Art, London
1977 'Silver Jubilee Exhibition of Contemporary British Sculpture', Battersea Park, London
'Silver Jubilee Exhibition of Contemporary British Sculpture, Battersea Park, in Microcosm – Maquettes, Drawings and Related Material', Redfern Gallery, London
'Biennale de Paris, une Anthologie: 1959-67', Paris
'British Artists of the 60s', Tate Gallery, London
Gallery Artists, Rowan Gallery, London
'Modern British Sculpture', DLI Museum & Arts Centre, Durham
'The First Sculpture Park in Royal Parks', Regent's Park, London, organised by the Department of the Environment
1979 Group Exhibition, Bernard Jacobson Gallery, London
'Six Large Sculptors in the Museum Gardens', Portsmouth City Museum & Art Gallery
'The British Art Show', Sheffield, Newcastle and Bristol, selected by William Packer
'Fine Art Treasures Exhibition', Somerset House, London
1980 'British Art 1940-80', Arts Council Collection, Hayward Gallery, London
'Growing Up with Art', Leicestershire Collection, Whitechapel Art Gallery, London
1981 Summer Exhibition, Guildford House Gallery, Guildford
'Artists in Camden', Kenwood House, London
1982 'British Sculpture in the Twentieth Century, Part 2', Whitechapel Art Gallery, London
'Aspects of British Art Today', British Council touring exhibition, Tokyo Metropolitan Museum and touring Tochigi Prefectural Museum, National Museum of Modern Art, Osaka, Fukuoka Art Museum, Hokkaido Museum of Modern Art, Sapporo
'Milestones in Modern British Sculpture', Mappin Art Gallery, Sheffield
1983 'Sculptures by Six Artists', Nishimura Gallery, Tokyo
1984 'Five Sculptors', Juda Rowan Gallery, London
'Festival Sculpture', International Garden Festival, Liverpool
1985 'Sculpture', Foundation Cartier, Jouy-en-Josas, France
'25 Years: Three Decades of Contemporary Art', Juda Rowan Gallery, London
1986 'Contemporary British Sculpture', Rotunda Gallery, Hong Kong
1987 'British Art in the 20th Century', Royal Academy, London
Krefeld Symposium, Germany, followed by touring exhibition
1988 Venice Biennale (*Shogun*)
1989 Exposition de Sculpture Anglaise, Musée du Havre
1990 'Contemporary British Sculptors, Studies on Paper', Connaught Brown, London
Royal Academy Summer Exhibition, London
1991 Royal Academy Summer Exhibition, London
Gardner Centre, Sussex University
'Sculpture and Sculptor's Drawings', William Jackson Gallery, London
1992 'The Spirit of Modernism', Austin/Desmond and Phipps

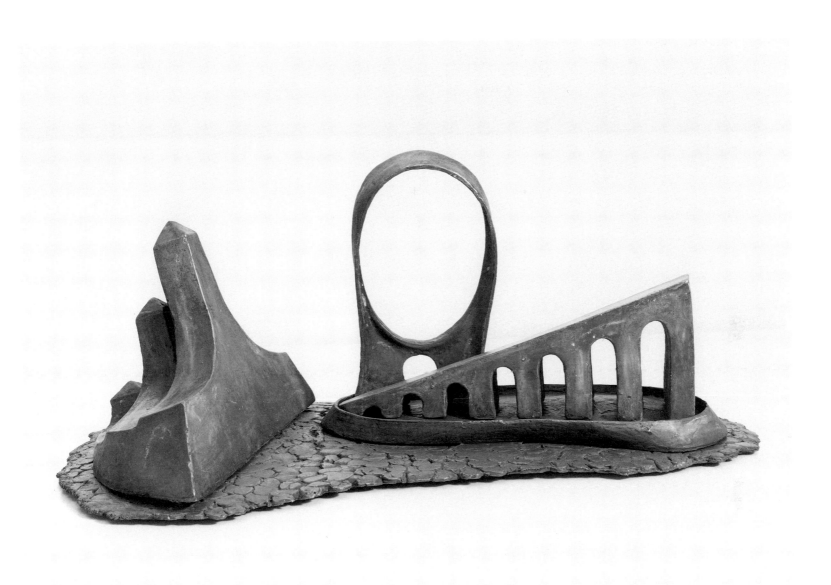

PLATE 34
Cartier Maquette 1989; bronze

PLATE 35
Judy in Garden 1990; bronze

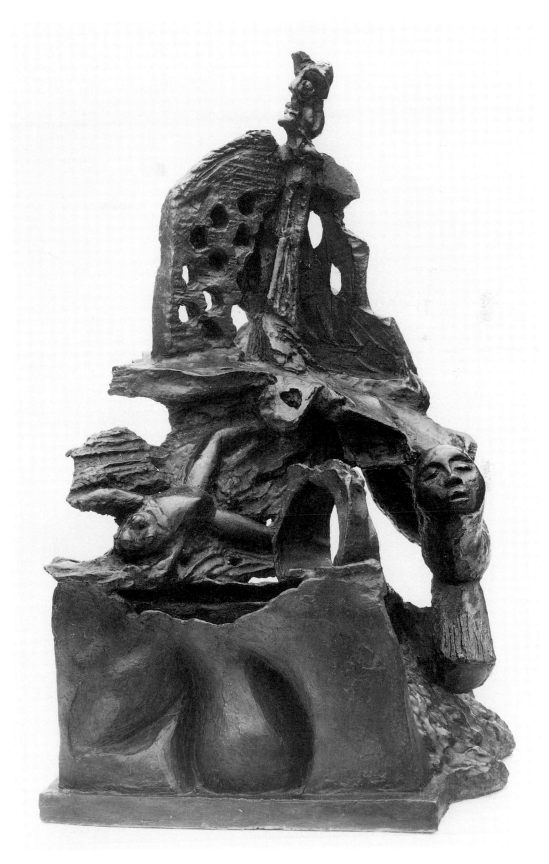

PLATE 36
Fire King No.2, Plop, the Frog Jumps 1989-90; bronze

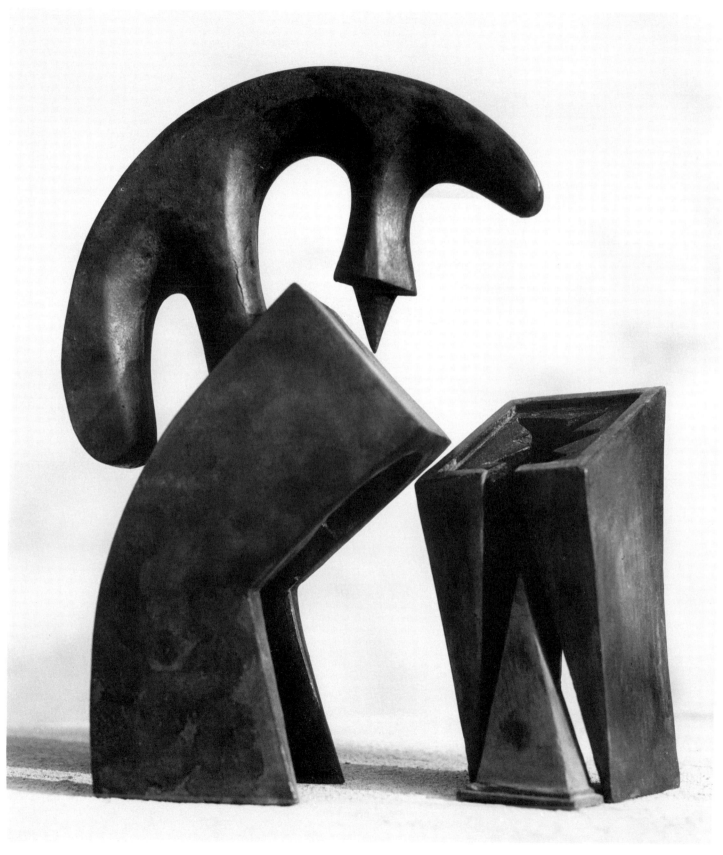

PLATE 37
Maquette for Toronto No.3 1991 ; polyurethane foam and resin

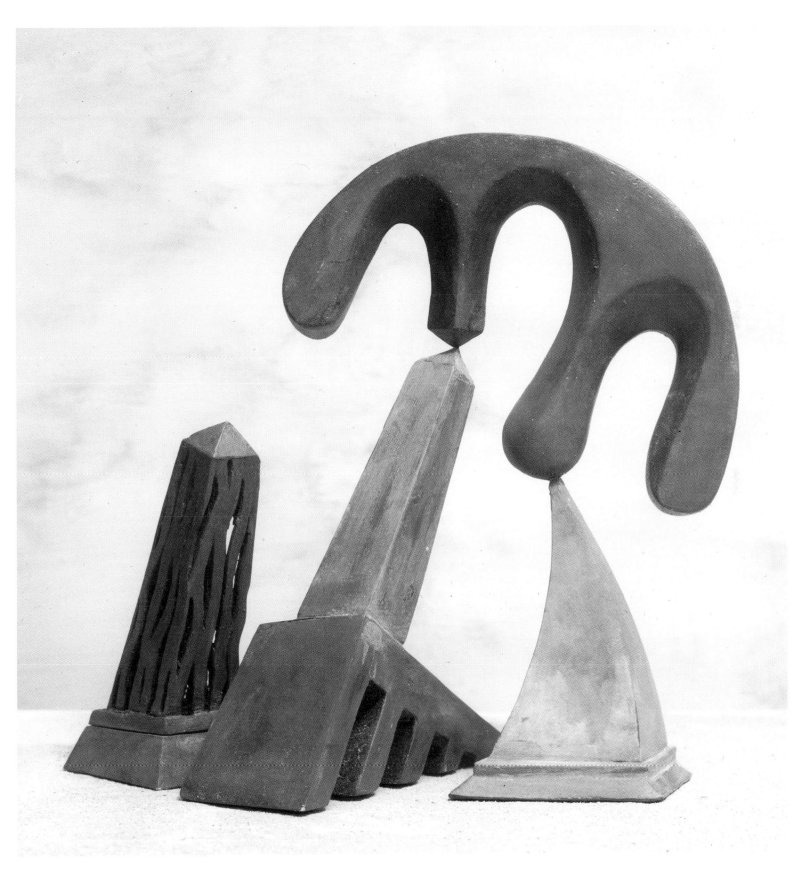

PLATE 38
Post Milton Keynes Maquette 1991 ; polyurethane foam and resin

PLATE 39
Fire King No.3, The Other 1991 ; bronze

PLATE 40
Fire King No.4, Water Hands 1991-2; wax for bronze

Public Collections

Arts Council of Great Britain
Art Gallery of New South Wales, Sydney
Bradford City Art Gallery
British Council, London
City of Rotterdam
Contemporary Art Society, London
Cultural Centre, Adelaide
Felton Bequest, Melbourne
Galleria d'Arte Moderna, Turin
Government Art Collection, Department of Education and Science, London
Calouste Gulbenkian Foundation, Lisbon
Hiroshima Museum of Contemporary Art
Rijksmuseum Kröller-Müller, Otterlo, The Netherlands
Leicestershire Education Authority
Leisure Centre, Osaka
Los Angeles County Museum
Louisiana Museum of Modern Art, Humblebaek, Denmark
Musée National d'Art Moderne, Centre Georges Pompidou, Paris
Musées Royaux des Beaux-Arts de Belgique, Brussels
Museum of Modern Art, New York
National Gallery of Australia, Canberra
National Gallery of Victoria, Melbourne
National Museum of Art, Osaka
New Museum of Contemporary Art, Hiroshima
Open Air Museum for Sculpture, Middelheim, Antwerp
Prefectural Museum of Contemporary Art, Toyama
Scottish National Gallery of Modern Art, Edinburgh
State University of New York College at Purchase, NY
Stuyvesant Foundation
Tate Gallery, London
Tel Aviv Museum, Israel
Ulster Museum, Belfast
Yale Center for British Art, USA

Commissions

1969	Iron and Steel Federation of Japan and Mainichi Press, for Expo '70, Tokyo
1972	C. & J. Clark Ltd, Street, Somerset
1978	European Patent Office, Munich
1979	Romulus Construction Limited, London
1987	*Moon in Taurus*, for Kita-Kyushu City, Japan
1987-8	New Museum of Contemporary Art, Hiroshima
1989	Chiba City, Japan

List of Works

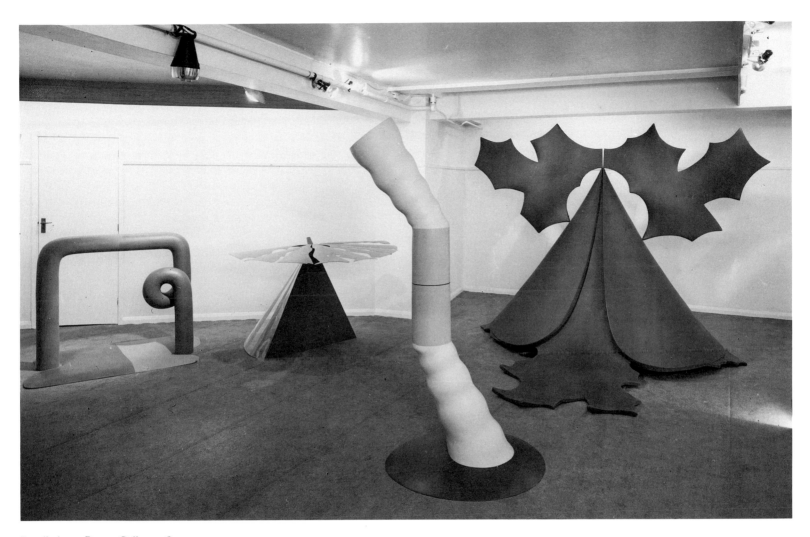

Installation at Rowan Gallery 1964:
Circlerette, Twilight, Ripple and Genghis Khan

Son of Man 1955
dry clay
40.5 × 40.5 × 61 cm (16 × 16 × 24 in)
Destroyed

Reclining Woman 1955
dry clay
14 × 25.5 × 10 cm (5½ × 10 × 4 in)
Artist's collection

Crouching Woman 1956
dry clay
20 × 20 × 15 cm (8 × 8 × 6 in)
Artist's collection

Crouching Man 1956
dry clay
17 × 17 × 14 cm (6¾ × 6¾ × 5½ in)
Artist's collection

Crouching Woman 1956
dry clay
15 × 20 × 15 cm (6 × 8 × 6 in)
Artist's collection

Sitting Man 1956
dry clay
15 × 12 × 15 cm (6 × 4¾ × 6 in)
Artist's collection

Bird Woman 1956
plaster
45 × 18 × 18 cm (17¾ × 7 × 7 in)
Artist's collection

Figure 1958
plaster
15 × 8.5 × 6 cm (6 × 3 × 2¼ in)
Artist's collection

Fighting Group 1958
plaster
15 × 9 × 10 cm (6 × 3½ × 4 in)
Artist's collection

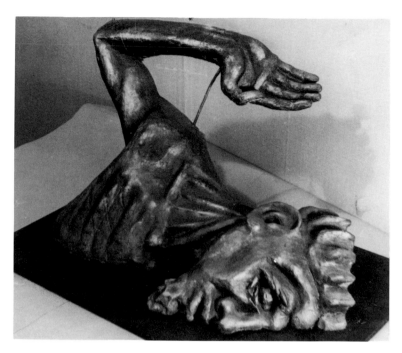

Son of Man, 1955

Reclining Woman, 1955

Crouching Woman, 1956
Crouching Man, 1956

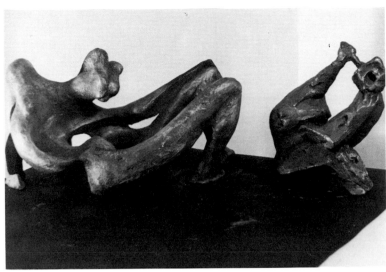

Crouching Woman, 1956
Sitting Man, 1956

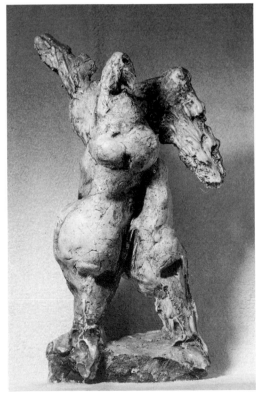

Bird Woman, 1958

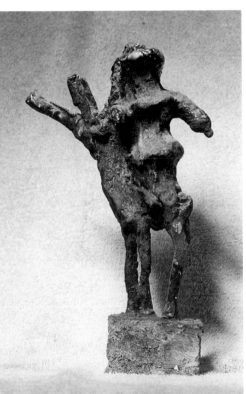

Figure, 1958

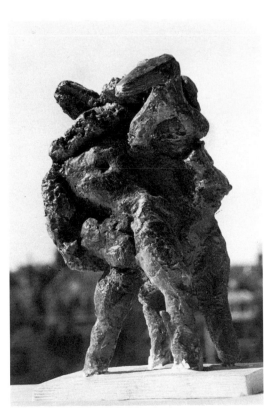

Fighting Group, 1958

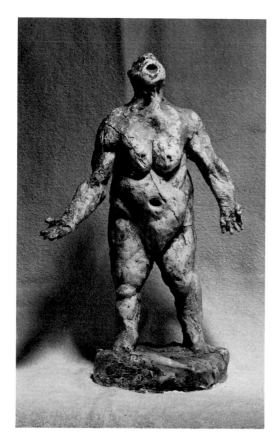

Standing Woman, 1958

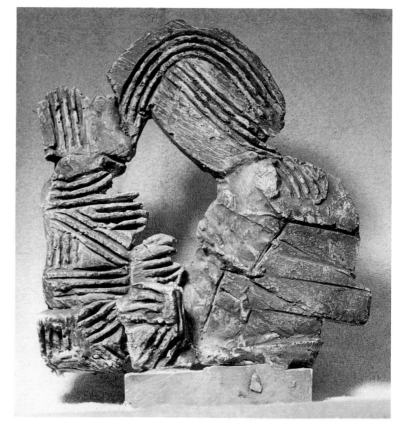

Mother and Child, 1959

Standing Woman 1958
plaster
31 × 25 × 20 cm (12¼ × 10 × 8 in)
Artist's collection

Mother and Child 1959
plaster
25.5 × 22 × 8 cm (10 × 8¾ × 3 in)
Private collection

Woman Flower 1959
bronze
15.2 × 17.8 × 17.8 cm (6 × 7 × 7 in)
Arts Council of Great Britain

Untitled 1960
plaster
47.5 × 110.5 × 47.5 cm (18¾ × 43¼ × 18¾ in)
Destroyed

Untitled I 1961
wood and plaster
152.5 × 91.5 × 244 cm (60 × 36 × 96 in)
Artist's collection

Untitled III 1961
wood and plaster
183 × 71 × 71 cm (72 × 28 × 28 in)
Artist's collection

Window Piece 1960-1 (pl.1)
concrete
173 × 122 × 38 cm (68 × 48 × 15 in)
New Rowan Gallery, London

Declaration 1961 (col.pl.1)
cement and marble chippings
84 × 208 × 84 cm (33 × 82 × 33 in)
Artist's copy
Original – Leicestershire Education Authority

Drift 1962 (pl.2)
concrete and wood
152 × 117 × 38 cm (60 × 46 × 15 in)
edition of 3
1 – Private collection, London
2 – Private collection, London
3 – Rijksmuseum Kröller-Müller, Otterlo, The
Netherlands

Rosebud 1962 (col.pl.2)
plastic
152.5 × 183 × 183 cm (60 × 72 × 72 in)
Artist's copy
Original – Museum of Modern Art, New York

Circlerette 1963 (pl.4)
plastic
114 × 127 × 76 cm (45 × 50 × 30 in)
Louisiana Museum of Modern Art, Humblebaek,
Denmark

Ripple 1963 (pl.3)
plastic
190.5 × 122 × 51 cm (75 × 48 × 20 in)
Calouste Gulbenkian Foundation, Lisbon

Twilight 1963 (col.pl.5)
plastic, aluminium and wood
102 × 132 × 168 cm (40 × 52 × 66 in)
Bryan Robertson, London

Tra la la 1963 (col.pl.4)
plastic
274 × 76 × 76 cm (108 × 30 × 30 in)
Tate Gallery, London

Genghis Khan 1963 (col.pl.3)
plastic
213 × 274 × 366 cm (84 × 108 × 144 in)
edition of 3
1 – Rowan Gallery, London
2 – Tate Gallery, London
3 – State University of New York

And the Birds Began to Sing 1964 (col.pl.6)
version 1 : plastic
edition of 2 : steel
168 × 213 × 213 cm (66 × 84 × 84 in)
edition of 2
1 – Tate Gallery, London
2 – Museum of Contemporary Art, Los Angeles

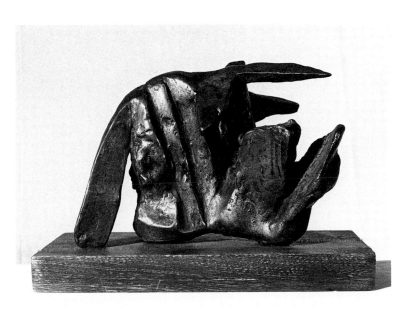

Woman Flower, 1959

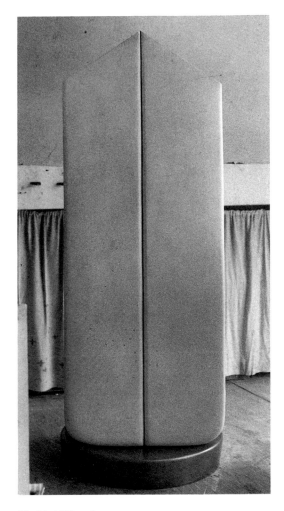

Untitled III, 1961

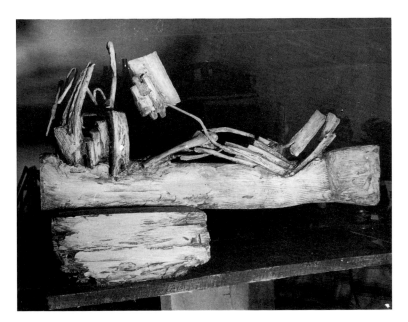

Untitled, 1960

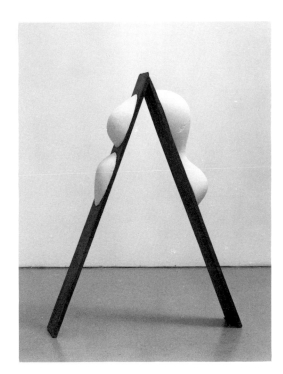

Untitled I, 1961

Barbarian Fruit 1964 (pl.5)
cast aluminium and steel
152.5 × 152.5 × 91.5 cm (60 × 60 × 36 in)
Rowan Gallery, London

Point X 1965 (col.pl.9)
plastic
183 × 188 × 152.5 cm (72 × 74 × 60 in)
edition of 3
1 – Feigen Gallery, New York
2 – Galleria dell'Ariete, Milan
3 – Arts Council of Great Britain

Through 1965 (col.pl.7)
plastic
213 × 335 × 274 cm (84 × 132 × 108 in)
edition of 3
1 – Tate Gallery
2 – Private collection, Italy
3 – Ulster Museum, Belfast

Brake 1966 (pl.6)
steel
213.5 × 366 × 488 cm (84 × 144 × 192 in)
edition of 3
1 – Rijksmuseum Kröller-Müller, Otterlo, The
Netherlands
2 – Private collection, Italy
3 – British Council

Slit 1966 (pl.7)
arborite
198 × 320 × 175 cm (78 × 126 × 69 in)
edition of 3
1 – Feigen Gallery, New York
2 – Private collection, Italy
3 – Musée National d'Art Moderne, Paris

Slant 1966 (col.pl.10)
arborite
213 × 457 × 190 cm (84 × 180 × 75 in)
edition of 3
1 – Feigen Gallery, New York
2 – Feigen Gallery, New York
3 – New Rowan Gallery, London

Span 1967 (col.pl.8)
steel
244 × 472 × 533 cm (96 × 186 × 210 in)
edition of 2
1 – National Gallery of Victoria, Felton Bequest,
Melbourne
2 – Rijksmuseum Kröller-Müller, Otterlo, The
Netherlands

Call 1967 (col.pl.14)
version 1 : plastic (destroyed)
edition of 2 : steel
442 × 457 × 549 cm (174 × 180 × 216 in)
edition of 2
1 – Tate Gallery, London
2 – Rowan Gallery, London

Nile 1967 (pl.8)
arborite and plastic
183 × 579 × 305 cm (72 × 228 × 120 in)
Tate Gallery, London

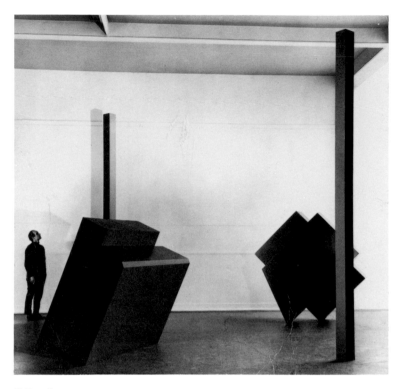

Call, 1967

Blue Blaze 1967 (col.pl.16)
aluminium
183 × 762 × 610 cm (72 × 300 × 240 in)
Private collection, Dallas, USA

Easter 1968
aluminium, steel, arborite
350.5 × 823 × 457 cm (138 × 324 × 180 in)
Private collection, Hamburg

Reel 1969 (col.pl.11)
stainless steel, aluminium and plastic
167.5 × 381 × 427 cm (66 × 150 × 168 in)
edition of 2
1 – Rijksmuseum Kröller-Müller, Otterlo, The
Netherlands
2 – Musées Royaux des Beaux-Arts de Belgique,
Brussels

Discs 1969
steel and aluminium
137 × 457 × 366 cm (54 × 180 × 144 in)
New Rowan Gallery, London

Sky 1969 (col.pl.13)
steel
396 × 1128 × 1128 cm (156 × 444 × 444 in)
Iron and Steel Federation and Manichi Press, Japan

Crest 1970 (pl.10)
aluminium
56 × 129.5 × 112 cm (22 × 51 × 44 in)
edition of 4
1 – Fitzwilliam Museum, Cambridge
2 – Tel Aviv Museum, Israel
3 – Bradford Art Galleries & Museum
4 – Private collection, USA

Dunstable Reel 1970 (col.pl.12)
steel
195.5 × 546 × 574 cm (77 × 215 × 226 in)
edition of 3
1 – Tate Gallery, London
2 – National Gallery of Australia, Canberra
3 – Leicestershire Education Authority

Quaver 1970
aluminium
117 × 69 × 79 cm (46 × 27 × 31 in)
edition of 2
1 – Private collection, London
2 – Alistair McAlpine, London

Green Streamer 1970 (pl.9)
steel
102 × 338 × 236 cm (40 × 133 × 93 in)
edition of 2
1 – Tate Gallery, London
2 – Museum of Modern Art, New York

Blue Between 1971 (col.pl.18)
painted steel
472.5 × 365.5 × 221 cm (186 × 144 × 87 in)
Art Gallery of New South Wales, Sydney, Australia

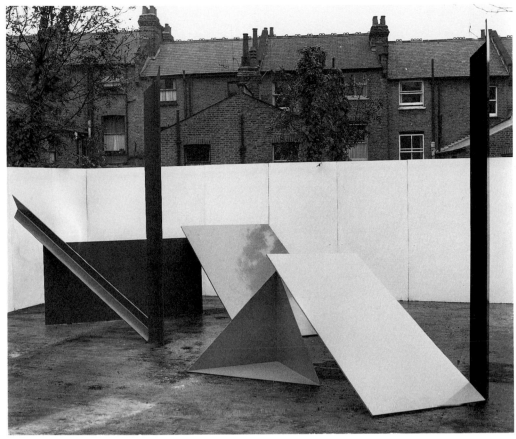

Easter, 1968

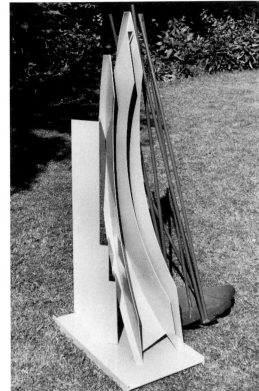

Quaver, 1970

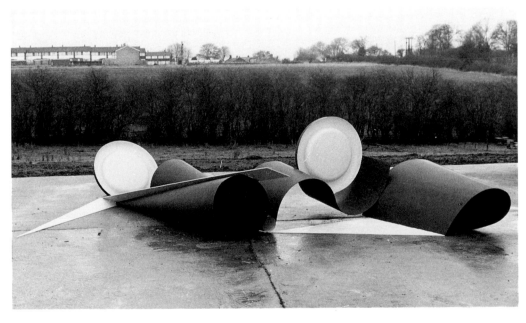

Discs, 1969

Yellow Between 1971 (col.pl.19)
painted steel
198 × 411 × 305 cm (78 × 162 × 120 in)
Festival Centre, Adelaide, Australia

Academy Piece 1971 (also known as *Sculpture 71*)
(col.pl.17)
mild steel and steel mesh, painted
115.5 × 640 × 640 cm (45½ × 252 × 252 in)
New Rowan Gallery, London

Quill 1971 (col.pl.15)
steel
427 × 1006 × 610 cm (168 × 396 × 240 in)
City Council, Rotterdam

Ascona 1972 (col.pl.20)
mild steel painted
231 × 457 × 457 cm (91 × 180 × 180 in)
Ulster Museum, Belfast

Diamond Maquette 1972
steel
82.5 × 63.5 × 63.5 cm (32½ × 25 × 25 in)
edition of 6
1 – Private collection, England
2 – Private collection, London
3 – Private collection, England
6 – Mrs Lilian King, London

Steps Maquette 1972
41 × 53 × 114 cm (16 × 21 × 45 in)
edition of 6
1 – Jean & Benbow Bullock, San Francisco
2 – Rijksmuseum Kröller-Müller, Otterlo, The
Netherlands, donated by Professor Pieter Sanders
3 – Private collection, London
4 – Private collection, England
6 – Mrs Lilian King, London

Calenzana 1972 (not ill.)
steel and glass with mesh
670.5 × 548.5 × 137 cm (264 × 216 × 54 in)
Galleria dell'Ariete, Milan

Red Between 1971-3 (pl.12)
steel
183 × 457 × 396 cm (72 × 180 × 156 in)
University of Liverpool

Open Bound 1973 (col.pl.22)
steel, aluminium, wood, steel mesh
167.7 × 366 × 366 cm (66 × 144 × 144 in)
'The Watcher'
steel
147 × 101.5 × 101.5 cm (58 × 40 × 40 in)
Rijksmuseum Kröller-Müller, Otterlo, The
Netherlands

Angle Poise 1973 (pl.11)
steel
99 × 386 × 91.5 cm (39 × 152 × 36 in)
New Rowan Gallery, London

Wall Piece 1969-74
aluminium
134.5 × 56 × 20 cm (53 × 22 × 8 in)
edition of 6
1 – National Gallery of Modern Art, Edinburgh
2 – Arts Council of Great Britain
3 – Private collection, USA
4 – Department of the Environment, London
5 – Private collection, England
6 – Mrs Lilian King, London

Maquette for New Orleans 1974
mild steel zinc sprayed and painted
73.5 × 58.5 × 38 cm (29 × 23 × 15 in)
edition of 2
1 – Private collection, USA
2 – Private collection, England

Brick Piece 1 1974
brick, aluminium mesh, steel sheet
39.5 × 42 × 28 cm (15½ × 16½ × 11 in)
edition of 6
1 – Private collection
2 – Private collection, Ohio, USA
3 – Private collection, London
4 – Galerie Gerald Piltzer, Paris
5 – Yale Center for British Art, USA
6 – Mrs Lilian King, London

Brick Piece 2 1974 (pl.14)
brick, aluminium mesh, steel
48 × 46 × 20 cm (19 × 18 × 8 in)
edition of 6
1 – Private collection
2 – Private collection, London
3 – Private collection, London
4 – Mrs Lilian King, London
5 – New Rowan Gallery, London
6 – Private collection, USA

Brick Piece 3 1974 (pl.15)
brick, aluminium mesh, steel
51 × 40.5 × 30.5 cm (20 × 16 × 12 in)
Private collection, London

Hannover Piece 1974
painted steel
82 × 143 × 59.5 cm (32⅜ × 56¼ × 23½ in)
edition of 2
1 – Private collection, England
2 – New Rowan Gallery, London

Sculpture 74 1974 (col.pl.23; pl.13)
concrete, steel and steel mesh
254 × 315 × 175 cm (100 × 124 × 69 in)
The Baltimore Museum of Art: Gift of Ryda &
Robert H. Levi

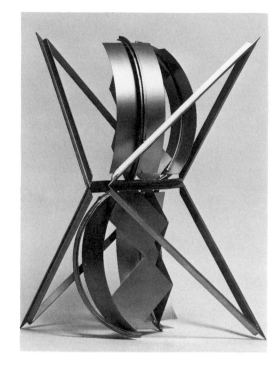

Diamond Maquette, 1972

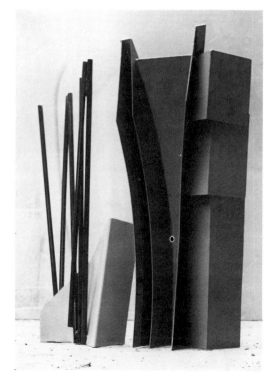

Maquette for New Orleans, 1974

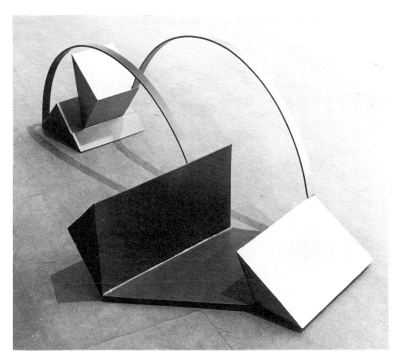

Steps Maquette, 1972

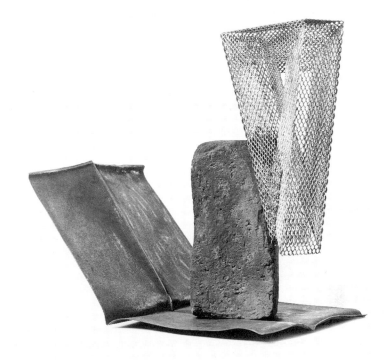

Brick Piece 1, 1974

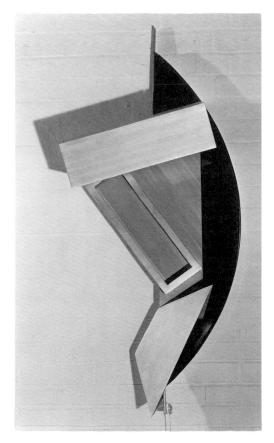

Wall Piece, 1969-74

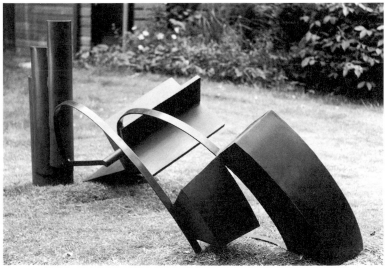

Hannover Piece, 1974

Brick Piece 4 1974
brick, steel, aluminium mesh
48.5 × 48.5 × 15 cm (19 × 19 × 6 in)
Bradstock Group plc, London

Diamond Sculpture 1974-5
steel
731.5 × 548.5 × 548.5 cm (288 × 216 × 216 in)
C. & J. Clark Ltd, Street, Somerset

Steps Sculpture 1974-5 (pl.16)
steel
366 × 457 × 1006 cm (144 × 180 × 396 in)
C. & J. Clark Ltd, Street, Somerset

Open (red-blue) Bound 1974-5 (pl.17)
steel mesh and plate, painted
366 × 366 × 213 cm (144 × 144 × 84 in)
New Rowan Gallery, London

Sculpture '75 (O Place) 1975 (col.pl.27)
zinc-sprayed steel, Welsh slate, wood, cord and
coloured tar
O Place: 202 × 104 × 217 cm (79½ × 41 × 85½ in)
Small piece: 29 × 84 × 79 cm (11½ × 33 × 31 in)
New Rowan Gallery, London

Rock Place 1976-7 (pl.19)
steel, steel cable, slate
91.5 × 85 × 85 cm (36 × 33½ × 33½ in)
Private collection, Antwerp

Sure Place 1976-7 (pl.18)
slate, steel and wood
124.5 × 195.5 × 299.5 cm (49 × 77 × 118 in)
New Rowan Gallery, London

Open Place 1977 (col.pl.21)
slate and steel
131 × 233.5 × 269 cm (51½ × 92 × 106 in)
National Museum of Wales, Cardiff

Bali 1977 (col.pl.24)
steel
180.5 × 233.5 × 355.5 cm (71 × 92 × 140 in)
Open Air Museum for Sculpture, Antwerp

Tracer 1977 (pl.20)
steel, steel cable and slate
76 × 64 × 56 cm (30 × 25¼ × 22 in)
Private collection, Canada

**Maquette for Munich Patent Office
Competition (Cross-bend)** 1978
steel
90 × 80 × 120 cm (35½ × 31½ × 47¼ in)
Chris Todd collection, Bedfordshire

Ring Rock 1978 (pl.21)
slate, steel and lead
91.5 × 66 × 66 cm (36 × 26 × 26 in)
Lily Modern Art, Jersey

Shiva's Rings 1978 (col.pl.25)
steel, steel cable, slate, wood
150 × 144 × 76 cm (59 × 57 × 30 in)
Arts Council of Great Britain

Within 1979 (col.pl.26)
slate, steel and wood
218.5 × 292 × 241.5 cm (86 × 115 × 95 in)
Tate Gallery, London

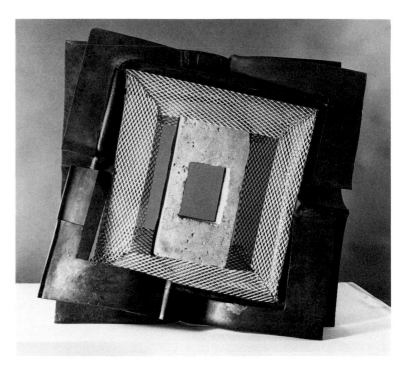

Brick Piece 4, 1974

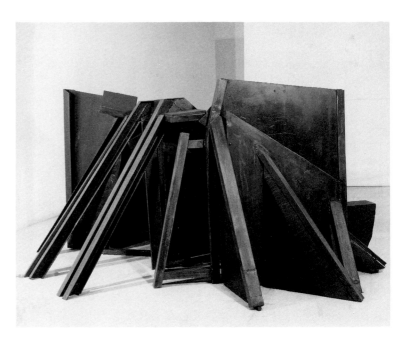

Open Place, 1977

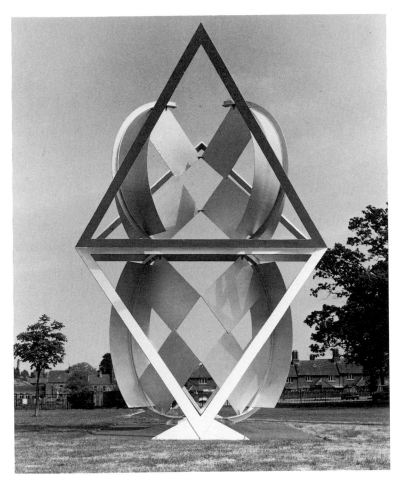

Diamond Sculpture, 1974-5

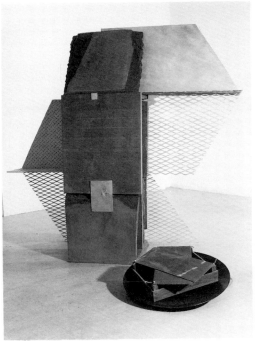

Sculpture 75 (O Place), 1975

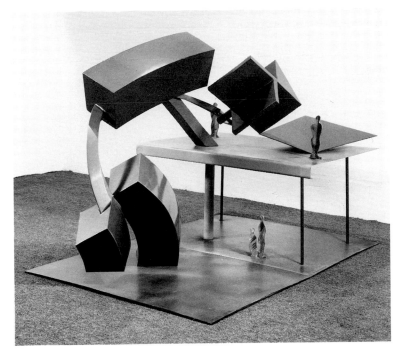

Maquette for Munich Patent Office Competition, 1978

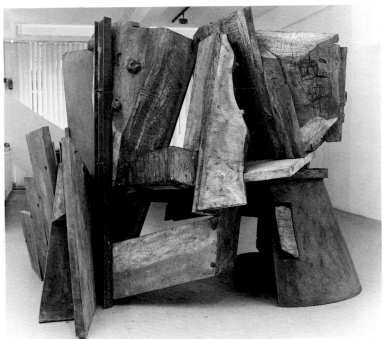

Within, 1979

Cross Over 1979
steel
43 × 70 × 46 cm (17 × 27½ × 18 in)
New Rowan Gallery, London

Cross-bend 1978-80 (col.pl.33)
steel
1068 × 1373 × 763 cm (420 × 540 × 300 in)
Commissioned by European Patent Office, Munich

Shogun 1981 (col.pl.28)
wood, steel and chain resin
216 × 254 × 200.5 cm (85 × 100 × 79 in)
New Rowan Gallery, London

L'Ogivale 1981 (col.pl.29)
steel
213.5 × 259 × 203.2 cm (84 × 100 × 80 in)
Government Art Collection, London

Clarion 1981 (col.pl.32)
steel
517 × 608 × 456 cm (204 × 239 × 180 in)
Romulus Construction Company Ltd, London

Head 1982-3 (pl.22)
steel and coloured tar
221 × 237 × 223 cm (87 × 93 × 88 in)
Hiroshima Museum

Spring-a-Ling 1983 (col.pl.31)
steelplate, mesh, steel cable and chain
195.5 × 216 × 138.5 cm (77 × 85 × 54½ in)
New Rowan Gallery, London

Snake Rise 1979-83 (pl.23)
steel
171 × 203 × 170 cm (67 × 80 × 67 in)
Hardin Gallery, Chicago, USA

Rivering Cross 1983 (pl.24)
slate and steel, varnished and painted
103 × 84 × 45 cm (40½ × 33 × 17¾ in)
Private collection, Germany

Moonstruck 1983 (col.pl.37)
painted steel
142 × 55 × 95 cm (56 × 21¾ × 37½ in)
Private collection, England

Bullgate-In 1984 (pl.25)
steel, bronze, cast iron, asphalt, wood
149 × 178 × 110 cm (58½ × 70 × 43 in)
Private collection, Atlanta, USA

Fire in Taurus 1984 (col.pl.38)
painted steel
153 × 188 × 136 cm (60 × 74 × 54 in)
New Rowan Gallery, London

Offering 1985 (pl.26)
steel and aluminium
70 × 56 × 40.5 cm (27½ × 22 × 16 in)
Private collection, USA

Judy's Butterfly 1985 (col.pl.34)
steel and aluminium, painted
91 × 63.5 × 63.5 cm (36 × 25 × 25 in)
Bo Alveryd, Vaumarcus, Switzerland

Shadow Player 1985-6
steel, cold asphalt and pebbles
161 × 107 × 90 cm (63½ × 42 × 35½ in)
Nishimura Gallery, Tokyo

Yellow Trapeze 1986 (col.pl.36)
steel
128 × 99 × 45 cm (50½ × 39 × 17¾ in)
Nishimura Gallery, Tokyo

Small Bronze Piece 1986 (pl.27)
bronze
32 × 26.5 × 25.5 cm (12½ × 10½ × 10 in)
edition of 6
New Rowan Gallery, London

Sun Bell 1986
steel
61 × 86.5 × 33 cm (24 × 34 × 13 in)
edition of 2
1–Nishimura Gallery, Tokyo
2–Private collection, London

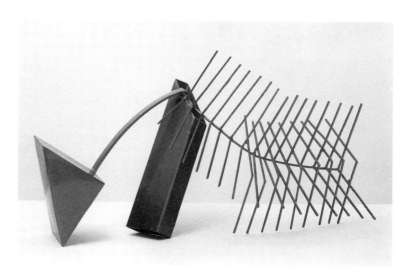

Cross Over, 1979

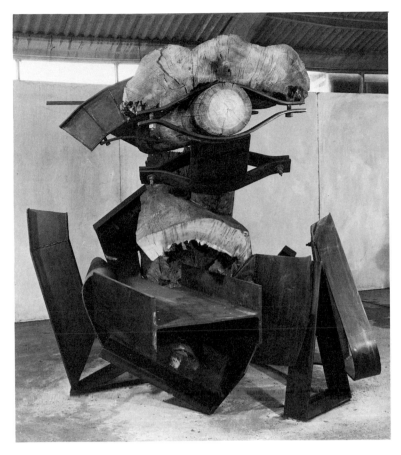

Shogun, 1981

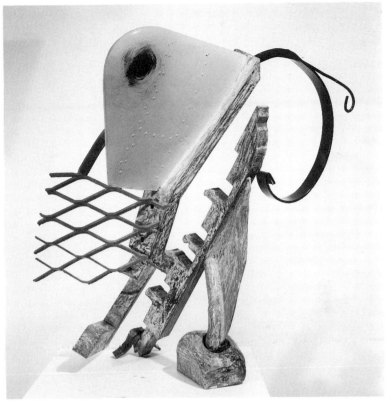

Judy's Butterfly, 1985

Shadow Player, 1985-6

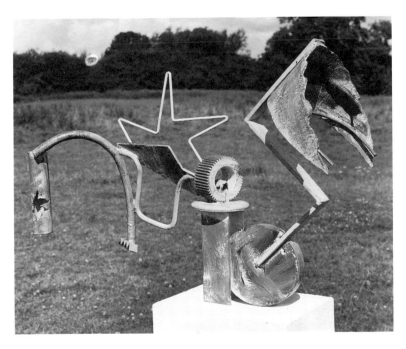

Sun Bell, 1986

Cavalcade 1986 (col.pl.30)
steel
220 × 177 × 79 cm (86½ × 69½ × 31 in)
New Rowan Gallery, London

Peaks and Chimes Variation 1986
bronze
24 × 30.5 × 19 cm (9½ × 12 × 7½ in)
New Rowan Gallery, London

Maquette for Monument for Hiroshima 1987
bronze
29 × 15 × 13 cm (11½ × 6 × 5 in)
edition of 6
1 – Private collection, England

Moon in Taurus 1987 (pl.30)
cast steel
518 × 445 × 295 cm (204 × 175 × 116 in)
Kita-Kyushu City, Japan

Maquette for Peaks and Chimes 1987
bronze
23 × 23 × 15 cm (9 × 9 × 6 in)
edition of 6
1 – Private collection, London
2 – Mayor Rowan Gallery, London
3 – Grob Gallery, London

Maquette for Moon in Taurus 1987
bronze
28 × 23 × 15 cm (11 × 9 × 6 in)
edition of 6
New Rowan Gallery, London

Peaks and Chimes 1987 (pl.28)
cast iron
244 × 366 × 183 cm (96 × 144 × 72 in)
edition of 2
1 – Private collection, Germany
2 – New Rowan Gallery, London

Take Aim 1988
bronze
30.5 × 51 × 29 cm (12 × 20 × 11½ in)
edition of 4
New Rowan Gallery, London

Heart 1988 (pl.29)
bronze
39.5 × 28 × 24 cm (15½ × 11 × 9½ in)
Private collection, London

Monument for Hiroshima 1987-8
steel, rusted and waxed
178 × 119.5 × 79 cm (70 × 47 × 31 in)
Hiroshima Museum

Cartier Maquette 1989 (pl.34)
bronze
23 × 55 × 35 cm (9 × 21¾ × 13¼ in)
edition of 4
New Rowan Gallery, London

Ubu's Camel 1989 (pl.33)
bronze
54.5 × 73.5 × 45 cm (21½ × 29 × 17¾ in)
edition of 6
New Rowan Gallery, London

Twilight Obelisk 1989 (pl.32)
bronze
34.5 × 37 × 29 cm (13½ × 14½ × 11½ in)
edition of 4
New Rowan Gallery, London

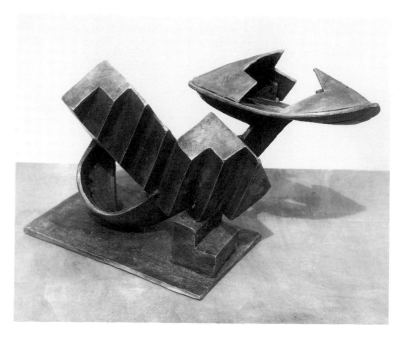

Peaks and Chimes Variation, 1986

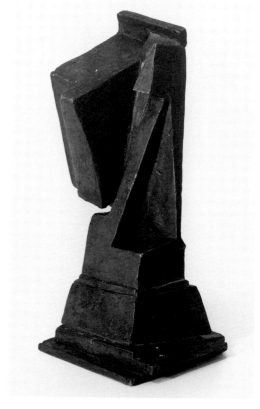

Maquette for Monument for Hiroshima, 1987

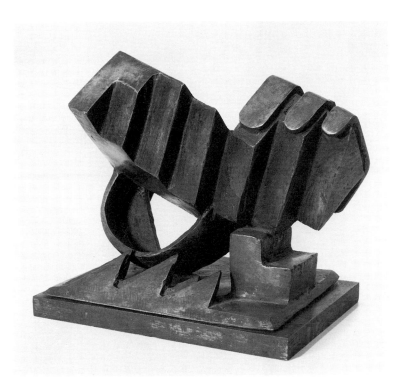

Maquette for Peaks and Chimes, 1987

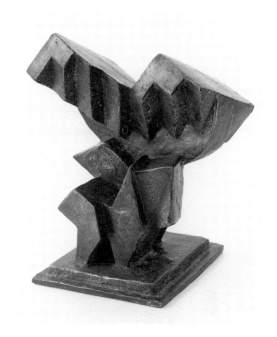

Maquette for Moon in Taurus, 1987

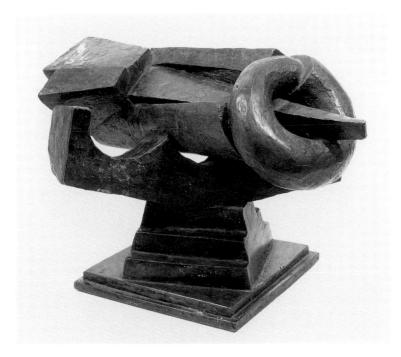

Take Aim, 1988

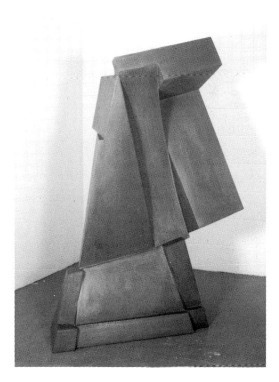

Monument for Hiroshima, 1987-8

It's a Swell Day for Stormy Petrels 1989
(col.pl.41)
fibreglass for bronze
200.5 × 470 × 520 cm (79 × 185½ × 205 in)
New Rowan Gallery, London

Maquette for Obelisk for Chiba City 1989
bronze
30 × 31 × 25 cm (11¾ × 12¼ × 9¾ in)
edition of 4
New Rowan Gallery, London

Sculpture for Chiba City 1989 (pl.31)
steel
380 × 396 × 396 cm (148 × 156 × 156 in)
Commissioned by Chiba City, Japan

Fire King No.1 1989-90 (col.pl.39)
bronze
71 × 89 × 51 cm (28 × 35 × 20 in)
edition of 4
New Rowan Gallery, London

Fire King No.2, Plop, the Frog Jumps 1989-90
(pl.36)
bronze
95.5 × 53 × 71 cm (37½ × 21 × 28 in)
edition of 4
New Rowan Gallery, London

The Mirror, the Bean and the Aqueduct 1989-90
(col.pl.42)
fibreglass for bronze
205.5 × 445.5 × 345.5 cm (81 × 175 × 136 in)
New Rowan Gallery, London

Frankfurt Maquette 1989-90
bronze
32 × 51 × 25 cm (12¾ × 20 × 9¾ in)
edition of 4
New Rowan Gallery, London

Where is Apollo Now? 1989-90 (col.pl.43)
fibreglass, epoxy resin, acrylic paint
331.5 × 310 × 68.5 cm (130½ × 122 × 27 in)
New Rowan Gallery, London

Obelisk for Tower Bridge 1989-90
bronze
39 × 44 × 32 cm (15¼ × 17¼ × 12½ in)
edition of 4
New Rowan Gallery, London

Sun, Bird, Worm, House 1986-90 (col.pl.35)
bronze
86 × 65 × 53 cm (34 × 26 × 21 in)
New Rowan Gallery, London

Judy in Garden 1990 (pl.35)
bronze
42.5 × 57 × 40.5 cm (16¾ × 22½ × 16 in)
edition of 6
New Rowan Gallery, London

Maquette for Hong Kong 1990
bronze
38 × 20 × 15 cm (15 × 8 × 6 in)
edition of 6
1 – Private collection, Egnland

Maquette for Rotterdam, Man in Sunshine 1991
steel, wood, fibreglass
42.5 × 57 × 40.5 cm (16¾ × 22½ × 16 in)
New Rowan Gallery, London

Post Milton Keynes Maquette 1991 (pl.38)
polyurethane foam and resin
30.5 × 33 × 25.5 cm (12 × 13 × 10 in)
New Rowan Gallery, London

Fire King No.3, The Other 1991 (pl.39)
bronze
89 × 45.5 × 56 cm (35 × 18 × 22 in)
edition of 4
New Rowan Gallery, London

Fire King No.4, Water Hands 1991-2 (col.pl.40;
pl.40)
wax for bronze
99 × 66 × 94 cm (39 × 26 × 37 in)
edition of 4
New Rowan Gallery, London

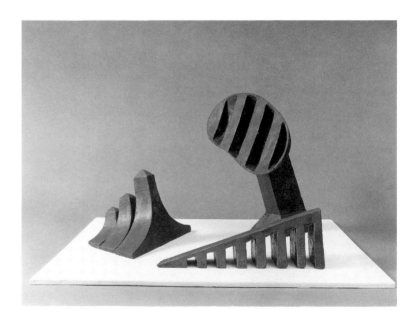

Frankfurt Maquette, 1989

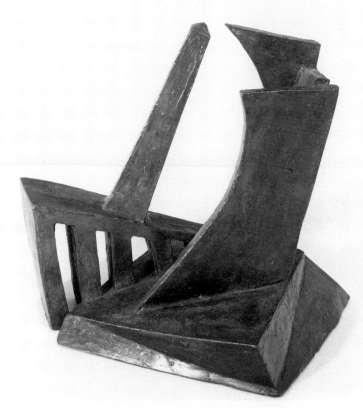

Maquette for Obelisk for Chiba City, 1989

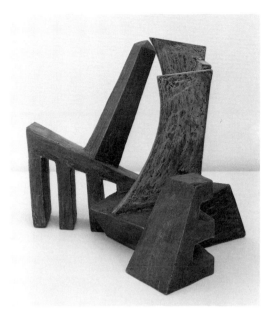

Obelisk for Tower Bridge, 1989

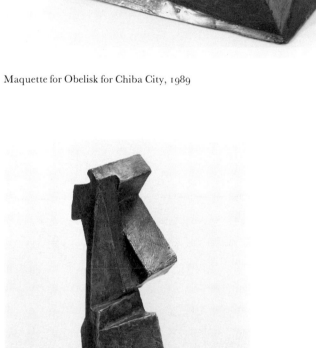

Maquette for Hong Kong, 1990

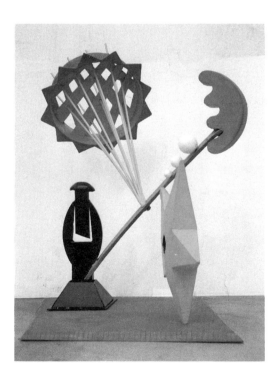

Maquette for Rotterdam, Man in Sunshine, 1991

Maquette for Toronto No.1 1991
polyurethane foam and resin
35 × 20 × 20 cm (13¾ × 8 × 8 in)
New Rowan Gallery, London

Maquette for Toronto No.2 1991
polyurethane foam and resin
25.5 × 25.5 × 15 cm (10 × 10 × 6 in)
New Rowan Gallery, London

Maquette for Toronto No.3 1991 (pl.37)
polyurethane foam and resin
35 × 20 × 20 cm (13¾ × 8 × 8 in)
New Rowan Gallery, London

Maquette for Birmingham 1991
27 × 70 × 60 cm (10¾ × 27½ × 23½ in)
polyurethane and fibreglass
New Rowan Gallery, London

Broadgate Maquette No.1 1992
polyurethane foam, resin and wood
66 × 44.5 × 33 cm (26 × 17½ × 13 in)
New Rowan Gallery, London

Broadgate Maquette No.2 1992
polyurethane foam, wood and aluminium, painted
75 × 35.5 × 38 cm (29½ × 14 × 15 in)
New Rowan Gallery, London

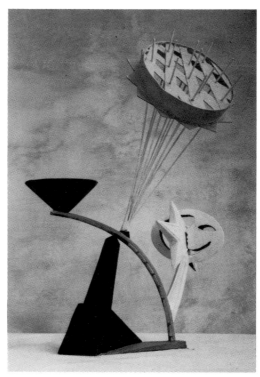

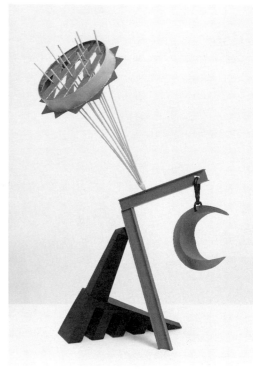

Maquette for Broadgate No.1, 1992

Maquette for Broadgate No.2, 1992

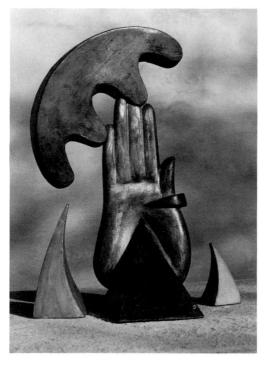

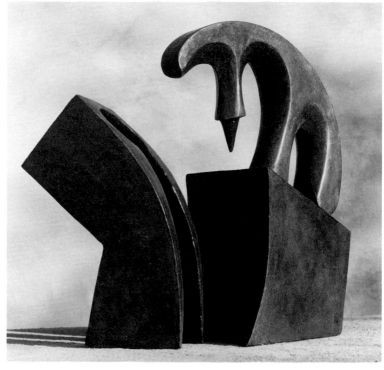

Maquette for Toronto 1, 1991

Maquette for Toronto 2, 1991

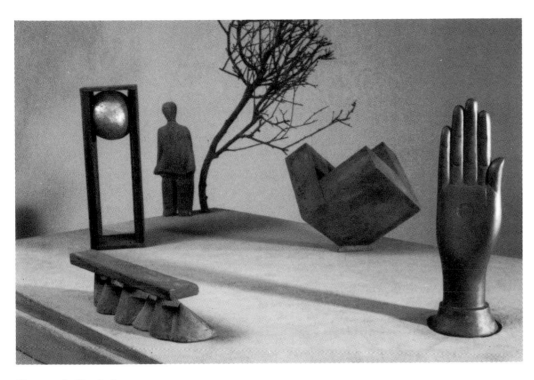

Maquette for Birmingham, 1991

Buddha, 1986

Buddha 1986
bronze
(cast in accordance to the Buddhist casting tradition)
50 × 35 × 30 cm (19¾ × 13¾ × 12 in)
Commissioned by the Thai Buddhist Community of
Great Britain for The Queen of Thailand to thank the
people of Thailand for their support

Selected Articles, Books & Reviews

1964 Coutts-Smith, Kenneth, *Arts Review*, 8 February, 'Phillip King'
Lynton, Norbert, *New Statesman*, 16 February, 'Three Sculptors'
BBC, February, 'Tonight'
The Times, 21 April, 'Proof of the Vitality of Recent Painting and Sculpture'
Lynton, Norbert, *Art & Literature*, No.2, Summer, 'Latest Development in British Sculpture'

1965 Robertson/Russell/Snowdon, *Private View*, Thomas Nelson & Sons Limited
Simon, Sydney, *Arts News*, April, 'Walker Art Center Exhibition'
Forge, Andrew, *Artforum*, May, 'Some New British Sculptors'
Baro, Gene, *Art International*, May, 'Britain's New Sculpture'
Russell, John, *Art in America*, June, 'The London Summer Season'
Baro, Gene, *Arts Magazine*, December, 'Britain's Young Sculptors'

1966 *The Times*, 20 May, 'Sculpture in the Light of Day'
Spencer, Charles, *New York Times*, 31 May, 'Sculpture for the Indoors'
Baro, Gene, *Studio International*, October, 'British Sculpture – The Developing Scene'
Barry, Edward, *Chicago Tribune*, 2 October, 'This Exhibit Took Plenty of Muscle'
Hudson, Andrew, *Washington Post*, 2 October, 'Bellwether of a Really New Sculpture'

1967 Finch, Christopher, *Konstrevy*, No.3, 'British Sculpture Today'
Russell, John, *Art in America*, May, 'Double Portrait – King and Riley'
The Times, 6 October, 'Young King on the Board'

1968 Lucie-Smith, Edward, *Art & Artists*, January, 'Phillip King goes to Paris'
King, Phillip, *Studio International*, June, 'British Artists at Venice, 2: King Talks about his Sculpture'
Mullins, Edwin, *Daily Telegraph Magazine*, 21 June, 'British Art at Venice'
Brett, Guy, *The Times*, 30 September, 'Three-Fifths of King's Output'
Kudielka, Robert, *Das Kunstwerk*, October/November, 'New English Sculptor'
Harrison, Charles, *Artforum*, December, 'Phillip King – Sculpture 1960-68'

1969 King, Phillip, *Studio International*, January, 'Colour in Sculpture', statement
Lucie-Smith, Edward *Movements in Art since 1945*, Thames & Hudson

1970 Hilton, Tim, *Guardian*, 10 July, 'Phillip King'
Russell, John, *Sunday Times*, 12 July, 'Reels of Poetry'
Gosling, Nigel, *Observer*, 19 July, 'A Secret Store'
Grinke, Paul, *Spectator*, 1 August, 'Star Turn'
Robertson, Bryan, *Spectator*, 22 August, 'Kingsize'
Lynton, Norbert, *Smithsonian*, November, '*British Art Today – not Quietly Dead but "Quietly Active"*'

1972 Russell, John, *Sunday Times*, 9 July, 'Kingly Style'
Blakeston, Oswell, *Arts Review*' 15 July, 'Phillip King'
Gosling, Nigel, *Observer*, 16 July, 'A New Mr Smith'
Brett, Guy, *The Times*, 18 July, 'Phillip King at the Rowan Gallery'
Wynn, Jones, Michael, *Flair*, September, 'Phillip King – Sculpture of Stature'

1973 Butt, James, *Apollo*, October, 'Structures in Space'
Shepherd, Michael, *Sunday Telegraph*, 14 October, 'Strong Dose'
Lucie-Smith, Edward, *Sunday Times*, 14 October, 'Sculpture from the Inside'
Vaizey, Marina, *Financial Times*, 23 October, 'Tucker and King'

1974 Thompson, David: Introduction, Oxenaar, Rudi: Ed. 'Phillip King' catalogue, Rijksmueum Kröller-Müller, Otterlo
Blotkamp, Carel: 'Sculptures & their relationship to time & surroundings', *Vrij Nederland*, 11 May
'Kunsthalle: Iron Sculptures by Phillip King', *Berner Tagblatt*, 20 October
Vaizey, Marina: 'The Shape of Change', *Sunday Times*, 7 July

1975 Fuller, Peter, *Arts Review*, 21 February, 'Phillip King'
Marle, Judy, *Guardian*, 3 March, 'Phillip King'
Feaver, William, *Financial Times*, 12 March, 'Phillip King'
Michel, Jacques, *Le Monde*, 18 May, 'La pureté sculpturale de Phillip King'
Lynton, Norbert, *Arts Council of Great Britain*, 'Sculptures by Phillip King' catalogue

1976 'Arte Inglese Oggi' catalogue, introduction: David Thompson and statement by Phillip King, Electa Editrice

1977 Lucie-Smith, Edward, *Illustrated London News*, Silver Jubilee issue, 'The visual arts transformed'
Osborne, Harold, *Arts Review*', 24 June, 'Sculpture in Battersea Park'
McEwen, John, *Spectator*, 25 June, 'Three shapes'
Glaves-Smith, John, *ARTmonthly*, July/August, 'Phillip King: Sculpture'
Robertson, Bryan, *Harpers & Queen*, September, 'Grounds for sculpture'
Lynton, Norbert, *Art International*, September, 'Phillip King'
Spencer, Charles, *Scultura (Italy)*, October/November, 'Silver Jubilee Exhibition of British Sculpture'
Lucie-Smith, Edward, *Art Today*, Phaidon Press

1978 McEwen, John, *Artforum*, April, 'Aspects of British Sculpture'

1979 Wilson, Simon, *British Art*, Tate Gallery
Feaver, William, *Observer*, 1 April, 'The Tree Within'
Wakely, Shelagh, *ARTmonthly*, No.26, May, 'Phillip King'
Cooke, Lynne, *Artscribe*, No.18, July, 'Phillip King's Recent Sculpture'

1980 *Fulham Chronicle*, 27 June, 'A Sculpture for Fulham Broadway'
Robertson, Bryan, *Harpers & Queen*, September, 'Export King'

1981 Colvin, Clare, *Observer*, 5 April, 'Phillip King's Clarion Call'
Vaizey, Marina, *Sunday Times*, 26 April, 'Phillip King: Sculpture as the Art of Euphoria'
Feaver, William, *Observer*, 26 April, 'Time to stand aghast'
Russell-Taylor, John, *The Times*, 28 April, 'Wit and colour enlighten the massively abstract'
Packer, William, *Financial Times*, 5 May, 'Phillip King'
Spalding, Frances, interview with Phillip King, *Arts Review*, 10 April
Cash, Tony, *London Weekend Television*, 17 May, 'South Bank Show'
Vaughan-Winter, Simon, *Artscribe*, No.29, June, 'Phillip King at the Hayward'
Januszczak, Waldemar, *Guardian*, 24 April, 'Smiling face of sculpture'

Shepherd, Michael, *Sunday Telegraph*, 3 May, 'Invisible exports'
Spalding, Frances, *Times Literary Supplement*, 15 May, 'The found and the made'
Harrison, Charles, *ARTmonthly*, June, 'What kind of discourse?'
Russell, John, *New York Times*, 28 June, 'Phillip King: In a challenging phase of development'
Packer, William, *Financial Times*, 1 August, 'King and Paolozzi in public'
Oxenaar, Rudolf, *Arts Council of Great Britain*, 'Phillip King'

1982 Harrison, Charles, *ARTmonthly*, February, 'British Sculpture in the Twentieth Century'
Packer, William, *Financial Times*, 5 January, 'This happy Heritage'
Newman, Michael, *Art in America*, April, 'British Sculpture: The Epirical Object'
Demarco, Richard, *Studio International*, September, 'Interview with Phillip King'
Murray, Peter, *Arts Review*, 22 October, 'Milestones in Modern British Sculpture'

1983 Feaver, William, *Observer*, 12 June, 'Boom and bust'
Feaver, William, *Observer*, 19 June, 'Phillip King'
Spurling, John, *New Statesman*, 17 June, 'Plain speaking'
Hooker, Denise, *Arts Review*, 10 June, 'Phillip King and Gottfried Honnegger'

1984 Packer, William, *Financial Times*, 3 January, 'Highlights amid the gloom'
Vaizey, Marina, *Sunday Times*, 6 May, 'The English art of cultivation'
Packer, William, *Financial Times*, 25 September, 'Body-building exercises the sculptor's mind'
Strachan, W.J., *Open Air Sculpture in Britain*, A. Zwemmer Ltd & Tate Gallery

1989 Dunlop, Fiona, *Artline*, December/January, Vol 4, No.4, 'Britannica'
Albertazzi, Liliana, *Contemporanea*, January/February, Vol II, No.1, 'British Sculpture'

1990 Hughes, Graham, *Arts Review*, 12 January, 'Mayor Rowan, British Council'
Robertson, Bryan, *Royal Academy Magazine*, Spring, 'Preview'
Lambirth, Andrew, *Royal Academy Magazine*, Spring, 'Frans Hals – A Chorus of Approval'
Vaizey, Marina, *Sunday Times*, 20 May, 'Making British tradition talk a witty new language'
Hilton, Tim, *Guardian*, 23 May, 'From the Ruins of Carthage'
CV Journal of Arts & Crafts, June–August, 'Phillip King'
Packer, William, *Financial Times*, 26 May, 'Occupied Spaces'
Lillington, David, *Time Out*, 30 May–6 June, 'Phillip King'
Cork, Richard, *The Listener*, 14 June, 'Exuberance Subdued'
Marlow, Tim, *ARTmonthly*, July–August, 'Phillip King'
Godfrey, Tony, *Art in America*, December, 'Phillip King at Grob and Mayor Rowan'
Hilton, Tim, *Guardian*, 27 December, 'When Photography Clicked'

1991 Dorment, Richard, *Daily Telegraph*, 6 June, 'The Dotty Charm of The Summer Show'